TOULOUSE-LAUTREC

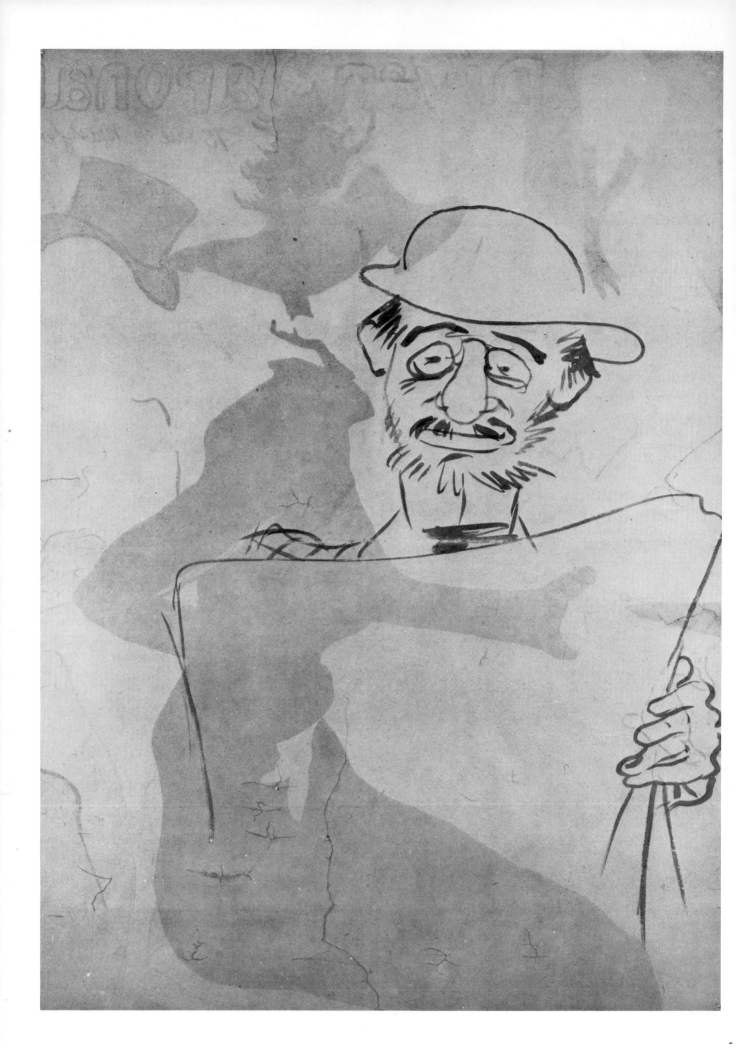

TOULOUSE-LAUTREC

RICHARD THOMSON

ORESKO BOOKS LTD·LONDON

(*frontispiece*)
Toulouse-Lautrec Reading a Newspaper
SWITZERLAND, private collection. 1898. Oil on paper 80 × 61·5 cm. Unsigned.

One of Lautrec's last images of himself, this self-portrait caricature is similar to another, also of 1898, in the collection of Mme. Dortu, Le Vestinet. Freely brushed onto the back of a poster, '*Le Divan Japonais*' (Plate 52), it shows the artist's proximity, on an informal occasion like this, to the brushmarks of Japanese painting. His cousin Tapié remembered that Lautrec kept a box of Japanese quills, brushes and inks so that he could experiment with the oriental calligraphic style.

ACKNOWLEDGEMENTS

I would like to take this opportunity to express my gratitude to a number of scholars and friends who have taught and encouraged me over the last few years, to Alan Bowness, Professor Tim Clark, Dr. John Golding, Professor Francis Haskell and Tim Hilton. As for this book, I must thank Christopher Wright for the initial prompting and Robert Oresko for his tact as its editorial god-parent. There were long conversations throughout several cool Albigensian evenings with Caroline Romer and Belinda Greaves, who later suggested some crucial amendments; I benefited also from chats with Juliet Steyn. My thanks go to Mary Price for the typing chores, to Kitty Covington, and finally to my parents for cars and optimism.

Sincere thanks are also due to the following for their help in providing photographs and information: Allen Memorial Art Museum, Oberlin College, Oberlin; Art Institute of Chicago, Chicago; Ashmolean Museum, Oxford; Bibliothèque Nationale, Paris; Boymans-van Beuningen Museum, Rotterdam; British Museum, London; Brooklyn Museum, New York; Cleveland Museum of Art, Cleveland; Courtauld Institute Galleries, London; estate of Henry Pearlman, New York; Fogg Art Museum, Cambridge, Massachusetts; Hermitage Museum, Leningrad; Kunsthalle, Bremen; Mr. Henry P. McIllhenny, Philadelphia; Mr. and Mrs. Paul Mellon, Upperville, Virginia; Metropolitan Museum of Art, New York; Musée des Augustins, Toulouse; Musée des Beaux-Arts, Lille; Musée des Beaux-Arts, Lyon; Musée du Jeu de Paume, Paris; Musée du Petit Palais, Paris; Musée Toulouse-Lautrec, Albi; Museum of Art, Rhode Island School of Design, Rhode Island; Museu de Arte, São Paulo; Museum of Fine Arts, Boston; Museum of Modern Art, New York; National Gallery of Art, Washington; Oskar Reinhart 'Am Römerholz' Collection, Winterthur; Phillips Collection, Washington; Pushkin Museum, Moscow; Rijksmuseum Vincent van Gogh, Amsterdam; Staatlichen Kunstsammlungen, Dresden; Sterling and Francine Clark Art Institute, Williamstown; St. Louis Art Museum, St. Louis; Tate Gallery, London; Thielska Galleriet, Stockholm; Victoria and Albert Museum, London; Von der Heydt Museum, Wuppertal; Wadsworth Atheneum, Hartford; Ets. J. E. Bulloz, Paris; Photographie Giraudon, Paris, and the Service de Documentation Photographique de la Réunion des Musées Nationaux. Finally, I would like to thank those private collectors who have kindly given permission to reproduce works from their collections.

For Jane, as I promised

First published in Great Britain by
Oresko Books Ltd., 30 Notting Hill Gate, London W11

UK ISBN 0 905368 16 9 (cloth)
UK ISBN 0 905368 17 7 (paper)
Copyright © Oresko Books Ltd. 1977

Printed in Great Britain by
Burgess & Son (Abingdon) Ltd., Abingdon, Oxfordshire

Library of Congress Cataloging in Publication Data

Thomson, Richard.
 Toulouse-Lautrec.

 (The Oresko art book series)
 Bibliography: p.
 1. Toulouse-Lautrec Monfa, Henri Marie Raymond de,
1864–1901. 2. Painters—France—Biography. I. Title.
II. Series.
ND553.T7T47 1977 760ı'092'4 (B) 77–21483
USA ISBN 0-8467-0372-6
USA ISBN 0-8467-0382-3 pbk.

Henri de Toulouse-Lautrec

'HE WAS A hunch-backed Don Juan, pursuing the ideal amid the most sordid realities,' wrote Edmond Lepelletier in *L'Echo de Paris* at the end of March 1899. 'The crass debauchery and those commercial-travellers' expeditions which Toulouse-Lautrec delighted to organize and in which he involved his friends, together with the irritation aroused by the awareness of his physical deformity and moral decadence, certainly helped to send him to the mad-house.' The occasion for this vituperative account was the artist's detention in a nursing home at Neuilly, where he had been taken to aid his recovery from acute alcoholism, but behind the gossip journalism, replete with its strident comparisons, there is a characterization of Lautrec that still deserves to be taken into account. Toulouse-Lautrec had acquired a notoriety in his own lifetime, for there are many statements like Lepelletier's, and the legend still obscures the true character of his work. Since Lautrec's death in 1901 his relations and friends have provided a vast amount of recollection that has added indispensable substance to any view of the man, and yet this body of fact has by no means dispelled the myth of the artist as the drunken bohemian of Montmartre. A certain amount of this information has to be sifted and structured to establish even a skeletal character, before it is possible to sketch the essential features of Lautrec's art.

Lepelletier's indictments ring true on several charges. The insinuation that Lautrec frequented Parisian brothels, for instance, was absolutely correct; in 1893 he had even supervised the decorations of a brothel in the rue d'Amboise. It was also true that Lautrec involved his friends, not only in sprees around Montmartre, but also in the entire fabric of his life. By all accounts he was dictatorial, forbidding his cousin Tapié de Céleyran to discuss politics, forcing Dethomas to extend their Dutch holiday for a whim, and this trait went hand-in-hand with his dread of being alone. Lautrec needed a constancy of companionship, and his friendships were numerous enough to supply this. The quality of the relationships helps throw light on other aspects of Lautrec's character. There was a traditionalism, perhaps, in his inclination towards close friendships with relatives, Tapié de Céleyran, Louis Pascal, Viaud; or a defensiveness in his favouring the company of artists lesser than himself, Rachou, Gauzi, Maurin,

Dethomas; even an absurd perversity in the tendency to be seen with much taller men, Anquetin or, again, Dethomas. But beneath all these features runs a much broader current essential to Lautrec's personality, a clannish instinct, a tribal mentality. Beginning with his upbringing in a large, provincial and heavily interrelated family Lautrec never ceased to live in well-peopled circumstances. The painting that is perhaps Lautrec's masterpiece can stand testimony to this. *At 'The Moulin Rouge'* (Plate V) has the artist placed centrally, offset by his lanky cousin Tapié beside him, strolling past a group of identifiable friends. It is a reconstruction of the complex of Lautrec's life, the cabaret and the performers, the friends and the women, an inclusive synthesis of a period of the artist's life on one canvas. His mature work is heavily reliant on the people it portrays, simultaneously depicting the subject's personality and Lautrec's current infatuation; the fact that his staffage is specific is fundamental to his art. Lautrec's responses to people, places and activities were primarily those of a great enthusiast and were coupled to an extraordinary energy. He rather staggered young William Rothenstein by wanting to take him first to an execution, then to an operating theatre; such powerful enthusiasms form the spine of his work. Sometimes a personality or model would interest Lautrec for a number of years, sometimes only for a week or two. La Goulue appears in his *oeuvre* with regularity from 1888 to 1892, whereas Marcelle Lender, subject of a sequence of lithographs and an important painting, seems to have obsessed Lautrec over the short period during which he watched her perform some twenty times in *Chilpéric* (Plate VII). Alongside this eagerness there was an energy that belied Lautrec's precarious health. There are sufficient anecdotes about his extraordinary ability to nap in a cab following a rowdy night before he arrived at the lithographic printers as it opened for the point to be proved. All these traits suggest a powerful personality, organizing his circle, absorbing experiences, equipped for work. But there was a fragility in Lautrec's make-up that can be sensed in the equivocation of his character, in the apparent ambiguities which complicate the picture. He chose to exhibit, for example, with both the advanced organizations, the Salon des Indépendants and Les XX, but also with the more conservative Cercle Volney.

Again, the notorious bohemianism contrasted with the dedication to family matters found in his letters. And Lautrec persisted in painting prostitutes and lesbians, bars and brothels, in the face of familial objections —his uncle Charles protested by burning some canvases at Albi in 1895—although his actions and letters show how the artist tried to prove to his family that he was a success at his chosen, if unconventional, profession. Throughout Lautrec's life there are strong indications that he made frequent and prodigal gestures, the drinking, of course, the most obvious, in order to show those around him that he was not a mere invalid, that he had not been totally incapacitated by his accidents.

Just as it is not possible to comprehend Lautrec's art without the man, it is impossible to understand the man without remembering his physical condition. The facts of this are simply related: in May 1878, the thirteen-year-old Lautrec fractured his left femur and in August of the next year broke the same bone in his right leg. Intermarriage, that proverbial aristocratic scourge, had weakened his bones, and after these two accidental fractures Lautrec's legs were not to grow again. So the son of Comte Alphonse de Toulouse-Lautrec-Monfa was unable to follow his father's aristocratic expectations and become equally renowned as horseman and huntsman. At almost five feet tall, Lautrec was above the minimum height for military service, but the psychological consequences of his tiny legs and the swollen, virile and rather ugly features which his metabolism had given him by way of ironic compensation were sufficient to drive Lautrec to the quasi-suicidal alcoholism that has so often been fully described. The work that he produced was to no small degree due to the desire to be noticed, to be admired, an attempt to surpass his condition as much as his drinking was an attempt to forget it. The alcoholism was to become simultaneously an addiction, an escape and, like the work itself, part of the legend.

Lautrec's early work can be dealt with promptly. After his accidents he was forced to live the life of an invalid, attended by his mother, dividing his time between various resorts and the family homes, Albi, Le Bosc and Céleyran. The years 1879 to 1881 saw Lautrec's childhood talent for draughtsmanship grow, as he compensated for his lack of mobility by spending his time drawing and painting. Naturally, the young artist took as his subjects what he saw around him, the local landscape, his family, labourers on the estates, horses and dogs. This was a time of great industry for Lautrec, as he began to use oils as well as to improve his drawing ability. The element of practice is fundamental to these works, and as studies of subjects to hand they include themes that were later dropped or shelved. Lautrec completely abandoned landscape when he settled in Paris, and even his interest in horses was not

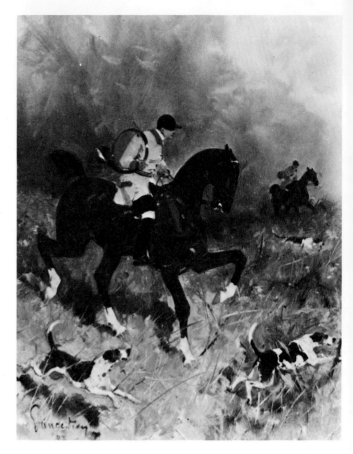

fig. 1 René PRINCETEAU
Huntsman with a Horn
Albi, Musée Toulouse-Lautrec. 1892. Oil on canvas 27 × 21 cm.

Pleasing the eye and depicting their life, Princeteau's (1839–1917) art is that of the gentry. Typical of his small easel pictures are the smoothly brushed horse and rider and the approximated landscape setting of this painting. It was from Princeteau that Lautrec picked up little schematic mannerisms, such as the particular arc of the horse's neck, that are so apparent in his early work.

to match the enthusiasm of his youth until the very last years of his career. These studies have been too frequently lauded as evidence of unbridled teenage virtuosity, while they are generally small in size and handled informally in oil on wood panel. Yet already they contain qualities that would continue to be of importance in Lautrec's work, although the studies were painted at a time when he was studying for his baccalauréat and both he and his family probably still considered his painting a pastime. The *Artilleryman Saddling his Horse* (Plate 1) indicates how, as early as 1879, Lautrec was inclining towards his mastery of depicting movement, evoking motion by a sureness of drawing and an equivalent speed in the brushwork. By 1881 these inclinations could be treated with greater sophistication, as in *The Mail Coach* (Plate 3), with its more complex motif and increased facility of touch. In the best of these early paintings of horses, such as

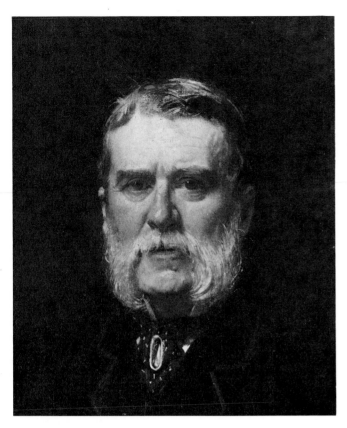

fig. 2 Léon BONNAT
John Taylor Johnston (detail)
New York, Metropolitan Museum of Art (gift
of the Trustees of the Metropolitan Museum
of Art). 1880. Oil on canvas 132·7 × 111·7 cm.

This portrait of the first president of the
Metropolitan Museum of Art is indicative of
both the international standing and the meti-
culous style of Bonnat (1833–1922). In 1905
Bonnat, a powerful figure in the French art
establishment, was instrumental in rejecting
Lautrec's portrait of *M. Delaporte at 'The Jardin
de Paris'* for the Luxembourg Museum. Bonnat's
antagonism might have been exaggerated,
however, as Thadée Natanson remembered
him admiring the *Revue blanche* album of prints,
including lithographs by Lautrec, about 1896.

The Mail Coach, the influence of Comte Alphonse's
friend Princeteau can be sensed. René Princeteau was
a fashionable painter of horses, of racing and hunting
scenes, and by the early 1880s he was giving advice to
Lautrec when they were both in Paris. Lautrec seems
to have derived from the elder painter something of
his schematic approach to drawing horses, and Prince-
teau's example (fig. 1) was probably in part responsible
for establishing Lautrec's attitude to the presentation
of the motif. The artist's tendency at this period to
couch a specific and quite carefully handled image in a
more abbreviated setting is indebted to the polished
genre tradition in which Princeteau worked.

Lautrec had also painted portraits and figures before
he entered into serious art-school training. As should be
expected, the teenager did not achieve a consistent
style, but these experiments were important for his
later work and produced some remarkable and enig-

matic paintings. While in his late teens Lautrec worked
through the fundamentals of his craft, testing the possibi-
lities of pigment and investigating the placement of the
figure in space. The *Self-portrait at Sixteen* (Plate 2) was
treated with greater seriousness than his contemporary
landscapes; in contrast its small brushstrokes are more
disciplined to clarify the forms and differentiate between
textures. With interesting sophistication Lautrec in-
cluded props, the clock and candlestick, to stress the
duplication of space between artist-sitter and artist-
spectator. By the time he came to paint the portrait of
his mother (Plate I) in 1881 Lautrec's preoccupations
had changed. Fine as it is, this portrait seems to embody
an early tension between the play of the brush, the
process of making the image, and the degree of recogniz-
able reality he needed or wished to attain. In this paint-
ing Lautrec made one of his most concentrated efforts
ever to come to terms with the possibilities of light, but
the construction of innumerable, fragmented touches
intended to evoke the light-filled room behind the figure
has a discreteness that does not tally with the un-
characteristically firm form of the coffee cup. This
painting sums up Lautrec's prompt arrival at a method
that was gestural, sweepingly brushed, rather than
painstakingly worked, with an instinctive awareness
of the *effective* level of finish which kept a surface live-
liness without excessive detail. The refinement of this
improvisatory and approximating manner was to
occupy Lautrec throughout the decade, with an inter-
val imposed by the more laboured approach insisted
upon by Parisian teaching ateliers.

At the end of March 1882, the seventeen-year-old
Toulouse-Lautrec was introduced to Bonnat's studio
by Princeteau and began to work there. Léon Bonnat
had a private studio in the Impasse Hélène, taking in
pupils with a view to their later attempting to enter the
Ecole des Beaux-Arts, the official and still reactionary
art school. Bonnat's own substantial reputation was
based largely on his portraiture (fig. 2), accurately
drawn, sombre in detail and serious in mood. Charac-
teristically, Lautrec worked hard, to judge by the large
number of drawings from the model (Plate 6) that have
survived. These do not show an adventurous or anarchic
pupil, and it is apparent both from these drawings and
from Lautrec's remarks about Bonnat—his 'lash was
good for me'—that these products of the life-class re-
present an attempt to correct the tendency to weakness of
form in Lautrec's earlier work. Nor, unsurprisingly, was
Bonnat without influence on Lautrec's portrait paint-
ing. The 1885 portrait of Emile Bernard (Plate 12) with
its firm, formal pose, blank background and careful
tonal approach is very much the work of a Bonnat
pupil. These features, combined with a darkening of
the palette, were the legacy of Lautrec's lengthy studio
sessions.

Bonnat closed the atelier in September 1882 on his

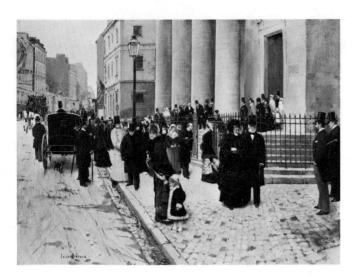

fig. 3 Jean BÉRAUD
The Church of Saint Philippe du Roule, Paris
New York, Metropolitan Museum of Art (gift
of Mr. and Mrs. W. B. Jaffe). c. 1880. Oil on
canvas 59·4 × 81 cm.

Like Lautrec, Béraud (1849–1936) was a
pupil of Bonnat. Once admired by Manet,
Béraud's highly detailed work epitomizes the
approach that van Gogh described as 'delusive
photography'. Contrasted with *First Communion*
(Plate 18), another picture of everyday reli-
gious life in Paris, this painting has a meti-
culousness and conventional spatial treatment
of exactly the type that Lautrec and his avant-
garde contemporaries found wanting.

fig. 4 Jean-Louis FORAIN
Dancer and Patron
Williamstown, Sterling and Francine Clark
Art Institute. Gouache and pencil 31·5 × 39 cm.

The work of Forain (1852–1931) contributed
to Lautrec's artistic formation before the
influence of the more refined example of
Degas. Forain worked in a number of different
media, oil, watercolour, gouache, although he
was perhaps best known as an illustrator,
providing drawings and prints for many
popular publications. Beginning with *La
Cravache* in 1876, he worked for *La Vie
moderne*, *Le Journal amusant*, *Le Rire* and *Le
Figaro* among others. Five of his illustrations
were included in Huysmans's *Croquis parisiens*
of 1880, the same year as the novelist wrote of
Forain's pictures in the fifth Impressionist
show, 'On his good days, M. Forain is one of
the most incisive painters of modern life that I
know.' Barbed from the first with a scathing
sarcasm foreign to Lautrec, Forain's art often
concerned itself directly with social and
political issues, for instance the fervid polemics
of the anti-Dreyfus stand that he took in
Psst, the magazine he founded in 1898 with
Caran d'Ache. Forain was a friend of Comte
Alphonse and his full-length portrait of the
top-hatted aristocrat was greatly respected by
the sitter's son. The *Dancer and Patron*, which
employs much the same imagery as Lautrec's
poster *Reine de Joie* (Plate 49), exemplifies the
gestural surface brushmarks that Forain's
small-scale, swiftly executed paintings made
available to Lautrec.

appointment as a professor at the Ecole des Beaux-
Arts and his pupils were taken over by Fernand Cormon
(1845–1924). As conservative as Bonnat yet lacking his
knowledge of the Old Masters, Cormon was not an
inspiring teacher. Lautrec complained in a letter to his
uncle Charles (10 February 1883) that Cormon was
more lax than Bonnat, and other letters voiced similar
complaints. Yet Lautrec continued to work hard, as
his fellow pupil Gauzi recalled. Apart from a few de-
sultory if energetic attempts at mythological and
history paintings (Plate 7), Lautrec concentrated on
drawing and began to look around him, to take advant-
age of what Paris could offer in the way of directions for
a young artist. If he stayed at the studio until about
1886 without apparent benefit from Cormon it was
because the atelier provided him with a place to
practice, models, a group of congenial friends and a
stable regularity from which to investigate the possibili-
ties of subject and style open to an artist in the 1880s.

Like any young artist Lautrec looked at a great deal
of work by other painters, experimenting with their
styles, formulating his own. His written account of the
Salon of 1884 evidences an unexceptional, unprogres-
sive appreciation of men like Delaunay and Carolus-
Duran, but already his flexible taste was edging towards
the more modern and individualist talents of the day.
Lautrec was clearly not to be satisfied with an instant

acceptance of the banal norms of the annual Salon.
A number of works from the mid-1880s indicate his
passing interests, for example a sizeable drawing of
an imaginary composition in a manner pillaged from
Fantin-Latour (Plate 8) and a free copy of a painting
by the fashionable Alfred Stevens (Plate 11). Lautrec
found a more potent option in Forain (fig. 4), whose
contemporary subjects, loose composition and angular
line provided the impulse behind works such as *The
Quadrille of the Louis XIII Chair* (Plate 13) and Lautrec's
earliest illustrations for newspapers and magazines like
the drawing *Gin Cocktail* (Albi, Musée Toulouse-
Lautrec, 1886). By 1886 Lautrec's orbit was closer to
definition. He found a studio at 7 rue Tourlaque, in the
same building as that of Zandomeneghi, like Forain a
protégé of Degas; he had established a group of friends
from Cormon's studio, Bernard, Gauzi, Louis Anquetin,
Adolphe Albert and Vincent van Gogh; he finally left
the teaching atelier; and he had befriended Aristide
Bruant (Plate IV) and began to frequent Montmartre.
Lautrec had a niche in the avant-garde.

The Parisian avant-garde in the second half of the
1880s was a fascinating and complex arena of talents
and interests, highly active, widely embracing. It was
an intellectual community which included writers and
musicians, poets and painters, whose artistic aims and
differences were flung wide in the directions of anar-

chism and colour theory, Wagner and Rosicrucianism. It produced many ephemeral magazines and reviews; it recognized even a geographical division of Paris between Symbolists on the Rive Gauche and in Montmartre the painters of everyday life. The intellectual breadth and internal turmoil of the avant-garde of the 'eighties can be ascribed, in part, to the presence of an earlier generation of avant-garde artists, not yet defused by the acceptance of the bourgeoisie. This was the Impressionist group and their literary fellows, the Naturalists, who were still fighting for the approbation they had tried to win in the 1870s and whose meagre notional foundations were responsible, by default, for the extremely theoretical nature of the subsequent avant-garde.

Lautrec was not attracted by the niceties of avant-garde concepts, but one rather general issue was crucial to his work. By the mid-1880s it had become a commonplace among most advanced artists that the painter should deal with subjects thrown up by the city. Paris, displaying her new rôle as an industrial metropolis at the Exposition Universelle of 1889, was the place where the themes of modern life could be found. Lautrec, following Forain and then Degas, eagerly accepted this iconographic radius, within which remained so much to be explored. Painters looked for the new—Seurat had the Eiffel Tower on canvas before it was even finished—and this suited Lautrec's enthusiasm: quite apart from his instinct for fresh music-hall talent, he was quick to represent the bicycle fashion (Plate 59) and even the motor car. Yet by mid-decade there was a proviso being added to the search for the modern subject. In 1884 Camille Pissarro had gone as far as to write to his son, 'The new is not to be found in the subject, but rather in the manner of expression.' It became increasingly important for the artist to have a personal style within the progressive idiom, hence Gustave Kahn's squabbles to establish his position as 'inventor' of *vers libre* or Seurat's words of 1888, 'I paint in this way in order to find something new, an art entirely my own.' It is this current that informs Lautrec, the need to establish a personal mode of expression

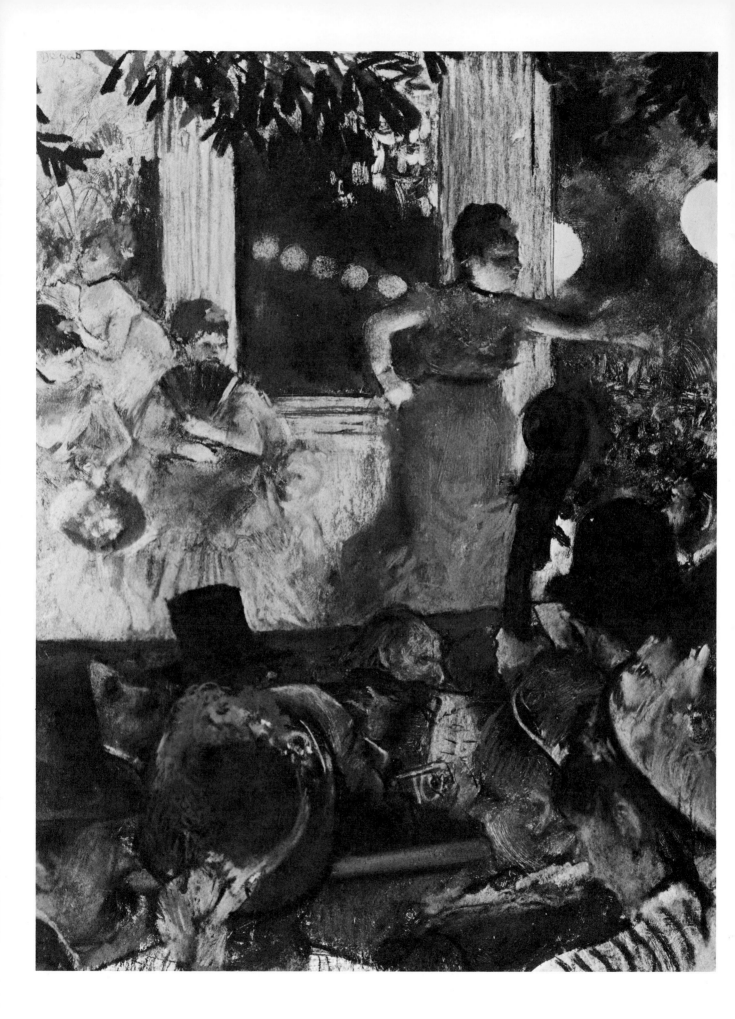

fig. 5 Edgar DEGAS
The Café-concert des 'Ambassadeurs'
Lyon, Musée des Beaux-Arts. c. 1876–77.
Pastel on monotype 37 × 27 cm.

This small picture serves to demonstrate Lautrec's standing as an artist compared to that of Degas. Advanced painting in the late '80s and the '90s demanded a more methodical and less complex presentation than had been the case of the 1870s, but the precepts behind Lautrec's work were not always the most advanced. He greatly respected Degas's *Orchestra at the Opéra* (Paris, Musée du Jeu de Paume, c. 1868), and this pastel is a more involved restatement of Degas's earlier compositional issues. *The Café-concert* has a subtlety of pictorial arrangement beyond Lautrec even at his best, with its perversely neutral-toned middle planes and Degas's insistence on activating both edges in all four corners.

and to tally this with an appropriately pertinent subject.

The avant-garde that Lautrec was infiltrating at this time was divided into a number of coteries and factions. Artists' argot recognized a distinction between the 'Grand Boulevard' and 'Petit Boulevard' groups, nicknames gleaned from the areas in which the dealers of these two informal bands had their shops. The 'Grand Boulevard' comprised the artists who had come to maturity in the 1870s and who in the 1880s were beginning to achieve success, Degas and Monet, Rodin and Pissarro, Whistler and Renoir. Painters of a younger generation made up the 'Petit Boulevard', men whose work had pushed beyond the perimeters of Impressionism and whose individual contributions had only recently been made, Seurat and Bernard, Anquetin and Signac, Lautrec, van Gogh and Gauguin. But among this latter agglomeration was a further ranking, fundamental to the understanding both of the milieu in which Lautrec's talent ripened and also to the decisions he made in his work. This younger avant-garde of the late 1880s was, in turn, divided into two factions, one centred on Seurat and the other on Gauguin, both offering different developments from Impressionism. Gauguin's synthetism, an art of 'naïve' drawing, firm contours and expanses of flat colour, vied with Seurat's Neo-Impressionism, with its pointillist brushwork, linear mannerisms and controlled colour, for primacy as the painting style of the avant-garde. These polarities did not dictate a static situation; personal, political and stylistic inclinations continued to fluctuate, and both Seurat and Gauguin were, in their different ways, aiming for a formula for a monumental, disciplined, modern art. But they did provide the progressive options that could not be ignored by the young artists of the avant-garde.

Lautrec's relationship with this community was complex. There can be no doubt that he had a rôle in the activities of the avant-garde, that he accepted responsibilities on its behalf. In 1888 he leapt at Théo van Rysselberghe's invitation to exhibit with Les XX, the enterprising Belgian modernist group, and two years later, at one of their Brussels banquets, Lautrec offered to fight a duel with the local painter de Groux, who had abused the work of the absent van Gogh. Nor did Lautrec shirk administrative tasks, serving, for instance, on the hanging committee of the Salon des Indépendants in 1891. But beyond these day-to-day commitments must lie more serious reservations about Lautrec's position. There are sufficient indications to suggest a deeper independence from avant-garde factions. What autonomy Lautrec possessed can be gauged from a number of approaches. He had a dislike for theory, evidenced by the few remarks about art that have survived from a man about whom so much is known, and this was against the grain of a number of his colleagues. Emile Bernard recounted that he was deterred from friendship by the people who met at Lautrec's studio, 'frequenters of bars and bad places', but it should be added that Bernard preferred discussing technique with Anquetin and others. Lautrec, although a convinced craftsman, appears to have played no rôle in the formulation of theoretical concepts on which to base a modernist manner. He did not, however, lack an antidote to the rarefied theorizing of acquaintances like Fénéon, Signac and Bernard.

This almost remedial alternative was Aristide Bruant. By 1886 Lautrec had become a regular client at Bruant's Montmartre cabaret, Le Mirliton, and a friend, even protégé, of the owner. The act Bruant gave at his own establishment consisted of self-penned songs delivered in a raucous voice, punctuated with foul-mouthed interjections aimed at the audience. His abrasive, repetitive lyrics made Bruant 'the poet of the exterior boulevard, of the Paris stews, of the bully and the harlot', as Will Rothenstein remembered. Lautrec drew several contributions for *Le Mirliton*, the cabaret's magazine, hung work in the cabaret itself, titled a number of female portraits after Bruant's songs (Plate 16) and produced several canvases and drawings which count among the first of his wholeheartedly Parisian pictures (Plate 13). Such was the importance of Bruant for the young Lautrec. Thus, the artist was prompted towards a specific subject matter, to a concentration on a particular entertainer, a particular establishment, a particular area of Paris. The encouragement that Bruant must have given him by printing his drawings should take a certain responsibility for Lautrec's flexible attitude to any work of art, a tolerance that he sustained through his career. Works of the Mirliton period have a shared practicality, depicting Bruant's environment, illustrating or accompanying his material. This body of work brings Lautrec, at the outset of his independent career, close to the famous illustrators of the day, to the men whose drawings featured heavily

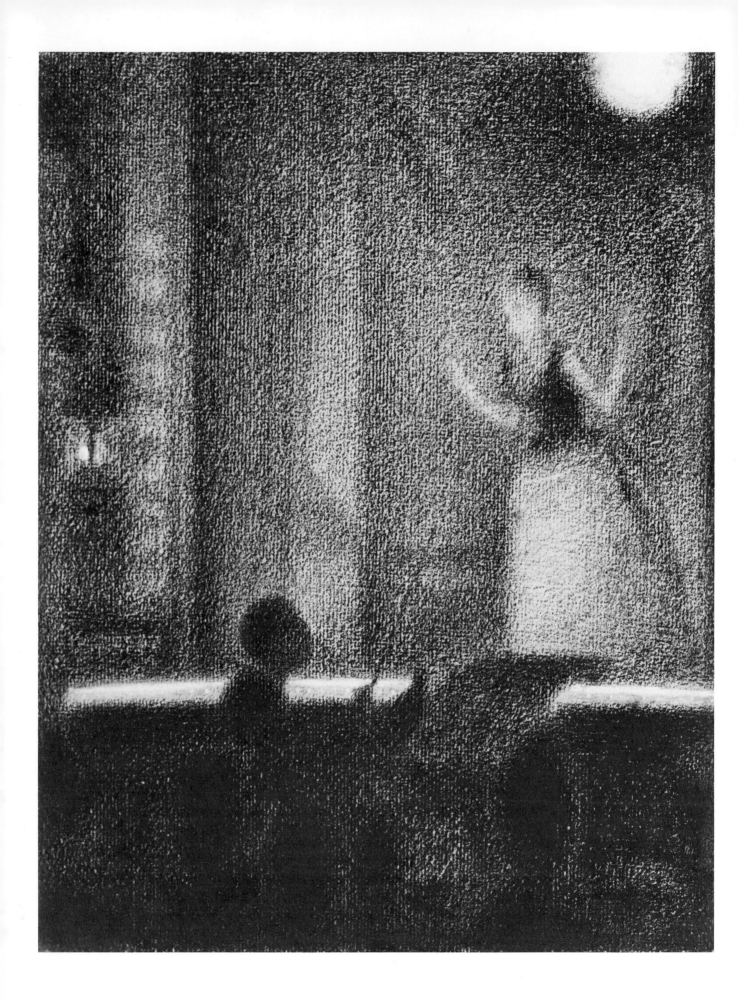

fig. 7 Paul GAUGUIN
Night Café
Leningrad, Hermitage Museum. 1888. Oil on canvas 73 × 92 cm.

In November 1888, while staying in Arles with van Gogh, Gauguin (1848–1903) wrote to Emile Bernard about the paintings he had finished there. 'I've also done a café that Vincent likes a geat deal but I like less. Really, it's not my sort of thing and the local colour, working class [canaille], doesn't suit me.' Gauguin had never been attracted to café and entertainment scenes, and this picture was obviously painted at van Gogh's instigation. However, with its perspective that pulls surfaces up towards the picture plane and its firmly contoured forms, the *Night Café* represents two of the stylistic features that made Gauguin an example to younger painters. Lautrec cannot have been unaware of these traits which were becoming common currency among advanced artists, often following Gauguin in his crucial, simplifying development.

fig. 6 Georges SEURAT
At 'The Gaîté-Rochechouart'
Cambridge (Massachusetts), Fogg Art Museum (bequest of Grenville L. Winthrop). 1887–88. Conté crayon and gouache 30·5 × 23·3 cm.

Seurat and Lautrec occasionally shared the same thematic territory. In this drawing of a café-concert the anonymity of Seurat's presentation of his subjects is most obvious, alongside Lautrec's divergent fascination with the performers' expressions and physiques.

in the popular magazines, Willette, Forain, Steinlen and Somm. But Lautrec was unable to broach the hegemony that these draughtsmen had imposed on their profession and this, paired with his inclinations as a painter, prevented his dedication to illustrative and topical work for the newspaper and magazine public. Nevertheless, the world of Montmartrois pleasures to which he had been introduced by Bruant and the workmanlike art with which it was served provided for Lautrec a tension with the ambitions to high art nurtured by the avant-garde.

Lautrec did not follow the anonymity imposed by Seurat on his iconographic choices and never adopted the Symbolist or religious vocabularies being investigated by Gauguin or Bernard. Rather he opted for the world to which Bruant had provided the *entrée*, to the café-concerts and dance-halls, the cabarets and brothels. Painters working in the city had long been attracted to themes of entertainment. These provided an intensity of colour and movement, a mood of artificiality in contrast to scenes of the street and drab daily costume, while, narrowing the focus, the entertainer, performer, or, more poignantly, the clown, could stand as the equivalent to the derided, unrecognized artist. Lautrec developed a great sensitivity to the pulse of this world. He dropped The Moulin de la Galette when the more exciting and modish Moulin Rouge opened in 1889; he had published an ambitious lithograph of Loïe Fuller only a few months after the dancer's arrival in Paris (Plate 41); he 'took in hand' May Belfort when she made her début in 1895 (Plate 55). The inconsistency of Lautrec's fascinations or, rather, the consistency with which he was able to harness his enthusiasm to the fashionable and the new, marked off his own iconographic territory. His instinct for the moment and his natural verve had developed an attitude to subject matter exactly attuned to the transitory nature of Parisian night-life. And his personal manner as a painter matured in tandem with this approach.

In the years between 1885 and 1891, Lautrec's painterly style was established; the distance between the relatively academic *Emile Bernard* of 1885 (Plate 12) and the fully personal *Paul Sescau* of 1891 (Plate 26), to take as examples two portraits, measures the artist's development. There can be little question that Lautrec took this formative period seriously, for as late as 1891 he was painting portrait studies in the garden of Père Forest, 'impositions' as he called them (Plate III), in which he explored problems of light, pose and physiognomy. As he drew away from Cormon's atelier, Lautrec continued to respond to the work of other artists. The daring to use heavily contoured and rather flat shapes for some of his figures, the woman in *The Laundryman* (Plate 45), perhaps, may have been indebted to Gauguin. Equally, a portrait of his mother painted in 1887 (Albi, Musée Toulouse-Lautrec), show-

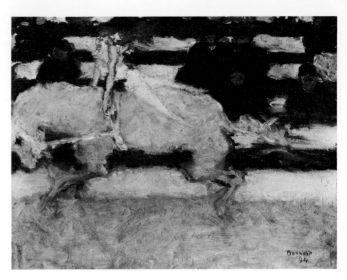

fig. 8 Pierre BONNARD
The Circus
Washington, Phillips Collection. 1894. Oil on wood 27 × 35 cm.

The circus was an unusual subject for Bonnard (1868–1947). His deliberately naïve drawing stands in contrast to the sophisticated virtuosity of Lautrec, but Bonnard's flat colour areas, though scrappily brushed, indicate his process for organizing oil paintings at this time. Exhibited by Vollard in either 1894 or '95 and at Bonnard's one-man show at the Durand-Ruel gallery in 1896, *The Circus* passed successively through the collections of Thadée Natanson, Lugné-Poë and Félix Fénéon.

fig. 9 Georges SEURAT
The Circus
Paris, Musée du Jeu de Paume. 1890–91. Oil on canvas 185 × 150 cm.

Lautrec had painted a large composition featuring a bareback rider at the Cirque Fernando in 1888 (Plate 20). Seurat (1859–91) could have seen this painting hung in The Moulin Rouge. His response is a more considered work, playing off the mannered movements of the performers against the hieratic stiffness of the spectators.

ing the comtesse reading and seated firmly in profile, suggests by its tiny and carefully placed touches an awareness of Seurat's procedures. And in one instance the relationship between Lautrec and the avant-garde leaders seems to have been reversed. It has long been accepted that Seurat's *Circus* (fig. 9) was planned with Lautrec's *Equestrienne* (Plate 20) in mind. The latter was certainly accessible to the Neo-Impressionist leader, and a degree of similarity is at once apparent, the comparable setting and figures, organized in a flattened space. Seurat died before *The Circus* was completed to his final satisfaction, while the Lautrec was sold, surely not a step the artist would have taken with a work he did not consider fully resolved. Yet it is Seurat's painting which is the more obviously controlled of the two. At this point Lautrec differed from the disciplined art for which

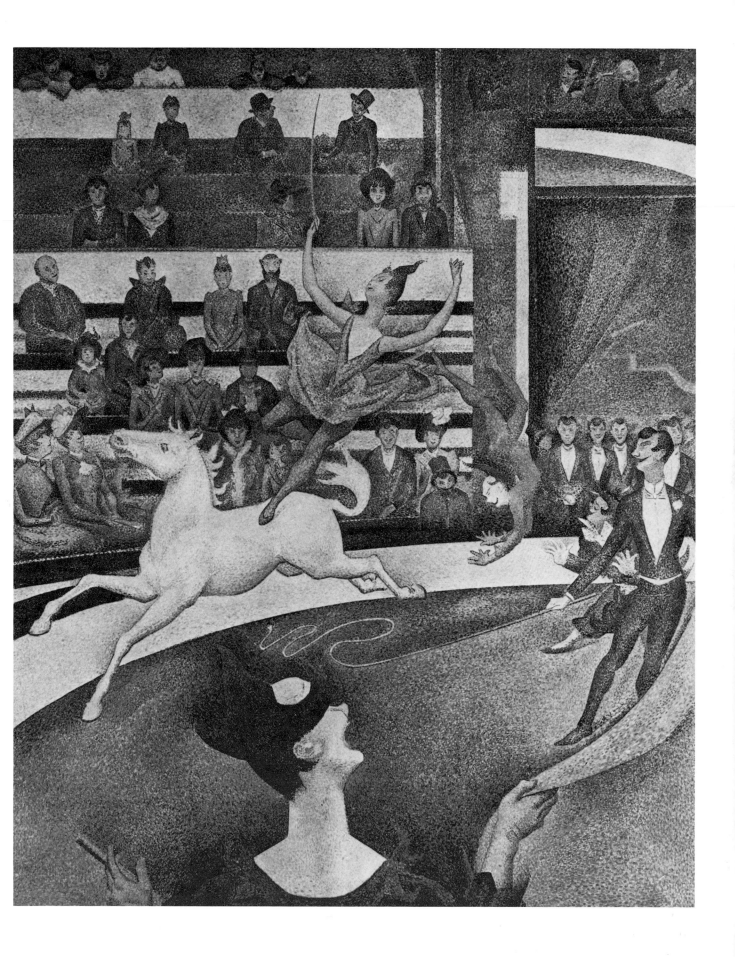

Seurat, Gauguin and so many of their associates were
striving. Lautrec's direct technical assimilations from
his immediate avant-garde contemporaries were usually
minor and generally unsatisfactory. He was tempera-
mentally unsuited to a painting that was thorough or
tidy, and the moments when Lautrec attempted to
impose such qualities on his work were rare and, pre-
sumably, experimental. The portrait of *Marie Dihau at
the Piano* (Plate II) of 1890 is one of those moments, an
interesting likeness somewhat jeopardized by the tex-
tural monotony of an overall patterning scheme that
fails to unify the surface adequately and clutters space.
Lautrec was attracted to his characteristic subjects be-
fore he had finalized his painting style, which was
evolved, in some degree, to cope with the pictorial
problems of interiors, artificial light, dancers and
crowds. Consequently he flinched from the slightly
rigid avant-garde options available to him in the work
of both Seurat and Gauguin and gave his attention to
the possibilities of Japanese art and to the Parisian who
had metropolitanized its devices, Degas. Although con-
flicting evidence makes it difficult to judge the personal
links between the two men, it is positive that Lautrec
held Degas in the highest esteem, just as it is well known
that Lautrec greatly admired Japanese art, poring over
Théodore Duret's fine collection of prints when it was
in Maurice Joyant's custody. Both Japanese prints and
the work of Degas shared and supported Lautrec's own
thematic inclinations, as well as providing crucial com-
positional authority. Rhythmic linear organization and
the use of unexpected angles of vision were two of the
most important qualities that Degas had derived from
the Japanese print, and it was these pictorial expedients
that Lautrec lifted from the work of his elder contem-
porary, because they gave a flexible idiom for the de-
piction of city life, crowded, glanced, varied. Japanese
art put a premium on line for the evocation of mass, and
this too Lautrec assimilated. These twin, vital influences
of Degas and Japan provided him with a repertoire of
pictorial ploys which were easily adapted to suit his
instinctively swift and gestural approach. Under most
of the figures in Lautrec's mature work is a sequence of
firm but mobile lines which build a scaffolding of form,
over which further long touches are brushed that give
colour while substantiating the forms. On occasion the
linear scaffolding was left bare, as in the brilliant *Alfred
la Guigne* (Plate 44). The characteristic striations in the
brushwork that overlays the structural lines of a Lautrec
has often been traced to van Gogh, whose touch, at least
at the time when he was in contact with Lautrec, was
heavier, shorter and less varied in length than Lautrec's.
The directness of Lautrec's surface strokes, superimposed

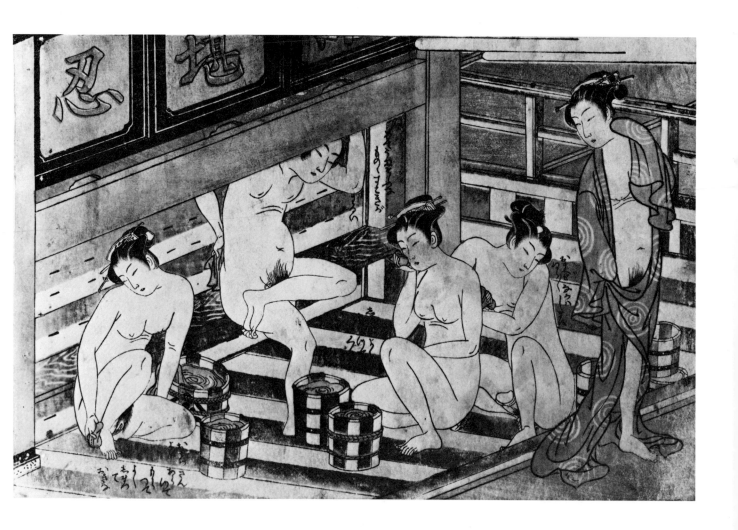

on the structure of the underdrawing, could possibly have been derived from Forain (fig. 4), to proffer an alternative. The most important similarity between the application of Lautrec and van Gogh is in fact the enlivening and energetic character of their peculiar brushstrokes, contrary to the more 'democratic', over-all surface of the Neo-Impressionists. Because compositional arrangement, active yet defining line and individuality of brushwork counted for so much of the effect he aimed to produce, Lautrec did not feel himself required always to cover the whole picture surface. He once complained to Tapié de Céleyran that people 'insist on my finishing things. All I want to do is paint what I see. Anybody can finish off a painting.' The implication of this, of course, was a repudiation of an exact rendition of reality in paint in favour of the artist's expressive and partial approximation; it is not surprising that one of Lautrec's favourite phrases was 'travaux d'approche'. There is an unconscious logic behind this. Lautrec's world was essentially one of mobile subjects, people in flux, and his handling was temperamentally rapid. The changeable nature of his enthusiasms, his motifs and his methods were bound to imply a satisfaction with the 'unfinished' work as a non-static totality. Some of the best of Lautrec's mature work, such as the sturdy *Lucie Bellanger* (Plate 60), is

based on the assumption that sufficiency of gesture is equivalent to finished work. Lautrec's colour, on the other hand, is neither as distinguished nor as potent as his handling, his drawing-in-paint, although it is undoubtedly individual. Taking advantage of the new chromatic freedom established by the Impressionists and their successors, he favoured quite large, open areas of colour in the paintings, loosened and rescued from absolute two-dimensionality by the marks of the brush recording the slight colour modulations. Thus, the paintings have a double layer of skin, a structure of firm drawing fleshed over by longer, looser strokes. By not attempting to model forms by tonal contrasts and plumping for artificial colours, mauves, light blues, dull crimsons and blanched greens, Lautrec pushed his painting away from strict naturalism for the sake of expressive effect. The simplified schema of colour areas was carried to its furthest degree in the deservedly famous posters. The lithographic process used for printing and the necessity for a striking effect meant that the poster would include bright and more or less unmodulated colour areas, around which ran single, clean lines by way of emphasis. The most imposing posters, like *Bruant aux 'Ambassadeurs'* (Plate IV), use very strong light and dark contrasts to achieve their striking presence, and this increased effect by reduction

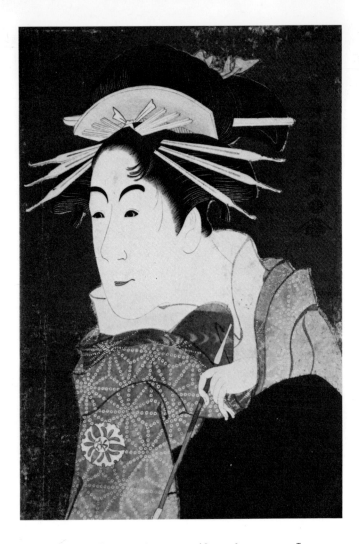

Lautrec's enthusiasm for the Japanese print
began soon after he had entered the Paris
studios; a letter of April 1882 mentions his
being shown 'a number of splendid Japanese
bibelots'. This taste never left Lautrec, and it
had a considerable impact on his art. Whereas
for many of the European artists who were
drawn to Japanese art at the end of the cen-
tury it held only formal interests, for Lautrec
the woodcut, discovered for western art in the
1860s, had a more extensive significance. The
ethos of the Japanese print seems to have meant
almost as much to him as its purely pictorial
promptings, the reproduceable nature of the
print perhaps encouraging his first forays into
lithography, the artists' casual attitude to ex-
hibition stimulating his own, the fascination
with the concept of the actor, the performance,
being mutual. This print, like many other
Japanese actor-portraits, is absolutely specific;
its full title is *Matsumoto Yonesaburō as Shinobu,
posing as Kewaizaka no Shōshō in the production of
'Kataki-uchi Noriai-banashi' at the Kiri-za in the
fifth month of Kansei 6.* Something of this pro-
tocol of the specific rubbed off on Lautrec's
conceptions, as well as Sharaku's reduction of
the face to a single surface plane, on which
the features are recorded in purely linear
terms, an approach adopted by Lautrec
(Plate 54).

of means was Lautrec's great gift to the poster. Lautrec
only began to challenge and revise these major techni-
cal characteristics of his art in the very last years of
his life.

In 1886 Lautrec refused an offer made to him by his
father concerning a studio near the Arc de Triomphe,
an area which would have removed him from the life
of Montmartre, the life that had just begun to fascinate
him. Yet this fascination was wearing thin by the early
1890s, as Lautrec began to tire of the can-cans and
music-halls and to seek a greater sophistication of
interest and, thereby, different subjects. His orbit
shifted. Lautrec left Montmartre increasingly for the
central boulevards and their more fashionable, less
rowdy pleasures, an alteration that brought with it new
friends and new places, hand in hand with a change of
imagery and an expansion of his means of expression.
There were larger transformations taking place in the
Paris art world in the years immediately after 1890, and
any variations in Lautrec's life inevitably had these as
a context. The avant-garde of the 1880s began to frag-
ment in the new decade: van Gogh died in 1890;
Gauguin was absent in Tahiti from 1891 to 1893 and
returned to the South Seas for good in 1895; the Neo-
Impressionist group was damaged by the defections of
Pissarro, Finch and van de Velde and, most importantly,

fig. 13 Vincent van GOGH
Woman Sitting in 'The Café du Tambourin'
Amsterdam, Rijksmuseum Vincent van Gogh.
1887. Oil on canvas 55·5 × 46·5 cm.

The café, situated in the avenue de Clichy,
was owned by a woman called La Segatori.
A former model and perhaps the mistress of
van Gogh (1853–90), it may have been she
who posed for this painting. In 1887 van Gogh,
Anquetin, Bernard and Lautrec exhibited
their work at The Tambourin, a haunt of
painters and writers. Such a gesture brought
together artists of the 'Petit Boulevard' circle
and emulated, as did Lautrec's work hanging
in Le Mirliton, the informal exhibiting customs
of the Japanese masters. Van Gogh's painting is
close to both Lautrec's *Jeanne Wenz* (Plate 16)
and his *Poudre de Riz* (Amsterdam, Rijks-
museum Vincent van Gogh, 1889), which was
bought by Théo van Gogh on his brother's
advice.

by the death of Seurat in 1891. There developed a new
stability, even a new tolerance, in the Parisian avant-
garde, symbolized by the very title of its most influential
magazine, *La Revue blanche,* chosen to be a standing
comment on an open-minded editorial policy that
respected contributions as varied as those of Zola,
Mallarmé, Jarry, Gide, Debussy and Proust. Linked
to the *Revue blanche* circle, the three brothers and pro-

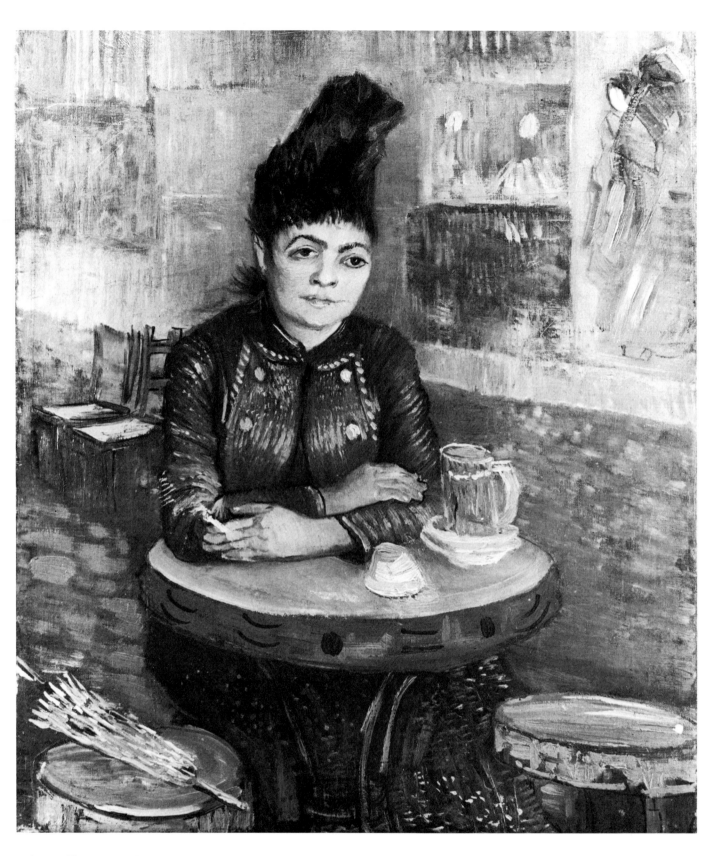

prietors Natanson, the poet Paul Leclercq, the jack-of-all-trades Tristan Bernard, the writer and libertine Romain Coolus and the great art critic Félix Fénéon, were other units of the new progressive vanguard. The theatre had recently been revitalized, most notably by the Théâtre Libre founded by Antoine in 1887 and Lugné-Poë's Théâtre de l'Oeuvre, which he opened in 1893. Related to both *La Revue blanche* and the theatrical renaissance was a group of young painters, the self-styled 'Nabis'. Of this coterie it was Bonnard and Vuillard, the two Nabis most concerned with the depiction of modern life, who were closest to Lautrec.

A new breadth in themes and media appeared in Lautrec's work about 1893, as he began to take stock of the changing scene. Although in the spring of that year he went to stay in the country with Bruant at

20

The most influential poster artist of Lautrec's day, Chéret (1836–1933) was widely respected for his bright and cheerful confections. Hailed as the 'Fragonard of the Streets', he was not only almost single-handedly responsible for the critical acceptance of the poster as an art form, but he also introduced innovations in technique. By about 1890 he had developed the poster in a number of directions, using up to five colours, achieving mixed textures by utilizing both lithographic ink and crayon, and had harnessed mechanical improvements to the increasing size of his images. Chéret had a considerable following among avant-garde artists and critics, including Lautrec, Seurat and Roger Marx, although Lautrec's own posters repudiated the tumbling baroque exuberance and broken, jangling contour of Chéret's manner for a more directly frontal presentation of simpler masses, bluntly phrased in large, open areas of colour.

Saint-Jean-les-deux-Jumeaux, in the later months Lautrec began to plunder the serious theatre, as well as his more usual café-concerts, for subjects. The famous lithograph *Sarah Bernhardt as Phèdre* (Plate 50), for example, was illustrated in *L'Escarmouche* on 24 December. In November Lautrec produced his first theatre programme for the Théâtre Libre, the design for the play *Une Faillite*. However, it was not until early 1894 that Lautrec began to have very close contact with the *Revue blanche* circle. In February took place the legendary party at Alfred Natanson's at which Lautrec, head shaven and dressed as a professional barman, mischievously devastated the cream of French cultural society with his cocktails. By the middle of the year the artist was obviously well entrenched in this new environment, producing illustrations such as the witty *Modern Judgment of Paris* (Adhémar 75) and making a rare venture into literary latitudes by collaborating with Tristan Bernard in a hilarious review of the official Salon, copy that was included in *Nib*, the comic supplement of *La Revue blanche*. Although it would be too emphatic to insist that Lautrec's new-born interest in subjects from the serious theatre was due to his circulation in more intellectual *cénacles* than he had previously frequented, he was evidently encouraged in this by his *Revue blanche* friends. His work in the theatre produced surprisingly few oils, a scruffy sketch of stagehands at the Opéra, one or two paintings of boxes and above all *Chilpéric* (Plate VII). Lautrec found that lithography was the medium he preferred for work on theatre motifs, and in 1894 a nice balance existed in his lithographic production between theatre and the once predominant café-concert subjects. As Adhémar

has pointed out, the lithographs of performances (Plate 51) emphasize the faces of the actors, whereas their bodies are more summarily treated, a formula that goes a long way towards explaining Lautrec's interest in the theatre. Lithography was an appropriate medium to be used as a vehicle for Lautrec's fascination with physiognomy. It was faster than painting, his impressions could be given form more quickly than in oils, and it even approximated dramatic art in that the lithographic print could be reproduced, retaining its originality, as many times as a theatrical performance, both being public and available forms. Lautrec's lasting interest in lithography, beginning in earnest with the posters of 1892, finding its stride in 1893, was not solely motivated by the facility with which he instantly managed the medium nor by the possibilities already mentioned to which such facility could be directed. He was also concerned with the technical, craftsman's approach to his work; he perfected the 'crachis' effect in lithography, spattering the stone with ink from an old toothbrush to achieve soft tonal and decorative effects, and he personally supervised the printing process whenever he could. There was a great deal of activity in the print-making field during the 1890s, and Lautrec, attuned to fashion as usual, flung himself into this new enterprise, running the whole gamut of possibilities for the lithograph, from the large, bright commercial posters to items for collectors' albums such as Roger Marx and Marty's *L'Estampe originale*, which flourished from 1893 to 1895. These exact years were an expansive period for Lautrec, not only with his new friends and interests, but also in his scope as an artist. The willingness he had shown in the 1880s to function as both an ambitious, exhibiting painter and as contributor of illustrations to small magazines was able to flourish in the atmosphere of the following decade, with the artist at the height of his powers. Lautrec was prepared to apply his talents on several levels, continuing to paint large oils such as *The Salon at the rue des Moulins* (Plate VI) or *Chilpéric* while designing theatre programmes and menus, even bringing oil painting almost into line with the commercial context poster in the huge panels painted in 1895 for La Goulue (Plates 32 and 33).

This range of activity on Lautrec's part was prompted by the general mood of Art Nouveau, the consciously 'modern' style of the 1890s. Emphasizing decorative effects, especially the arabesque, Art Nouveau attempted to cultivate a relationship between all the arts, breaking down distinctions between 'high' and 'low' art. Lautrec was aware of this movement, bringing with him decorated crockery and a Lemmen rug when he returned from Belgium in 1894, a journey during which he had been entertained by van de Velde, a leading exponent of Art Nouveau. But although Lautrec was prepared to respond to the options opened up by Art Nouveau, his stylistic approach to it was wary. His

Vallotton (1865–1925) allied himself stylistic-
ally to the Nabis circle of Denis, Bonnard,
Vuillard and Maillol in the early 1890s.
Although best known for his remarkable black
and white woodcuts, yet another instance of
the revival of print-making at this time,
Vallotton produced a number of oils which,
with their decorative distillation of the com-
positional features, show a pictorial radicalism
that Lautrec rarely emulated but which he
quoted on occasion, for instance, *Aux
'Ambassadeurs'* (Plate VIII).

highly linear manner was potentially well attuned to
the extravagances of the Art Nouveau arabesque, but
his reticence and independence kept his work apart
from it. Yet on occasion, as in his vision of Loïe Fuller
(Plate 41) or in the poster for *Mlle. Eglantine's Troupe*
(Plate 68), he gave free rein to his skill for compounding
a design from a moving line. Equally, there were
moments in the early 'nineties when Lautrec's proxi-
mity to the Nabi coterie becomes apparent in his
oeuvre; the flat colour areas of *Aux 'Ambassadeurs'*
(Plate VIII) are not far removed from the work of, say,
Vallotton (fig. 15). But, in general, Lautrec steered
clear of fashionable mannerisms or abrupt borrowings,
being by this point a mature artist whose own hand as a
draughtsman and painter was well established. The
changes that had taken place around Lautrec and had,
in some instances, affected his life managed to make no
startling variations to the execution of his paintings.
But his range as an artist, both in subject and media,
had been considerably extended.

At much the same time as Lautrec broadened his
sphere of activity to include the legitimate theatre of
the boulevards he interested himself in an iconographic
counterpoint, the brothel. The underworld of prosti-
tution and vice is present in the earlier dance-hall
paintings—Jane Avril was a kept woman, La Goulue
had spent a night with the Prince of Wales—and
Lautrec's blunt adoption of the brothels as a subject
was merely a logical step. Prostitution was not dis-
covered for painting by Lautrec; it takes a turn in the
work of Manet, Degas, Raffaëlli and Rops, but with a
thematic irregularity or artistic irresolution that Lau-
trec altered. It was characteristic of Lautrec that he
should treat any thematic venture with a concentrated
consistency, and his work in the brothels was as much
a painting 'campaign' as, say, Monet's work at Varenge-
ville or Rouen. Between 1892 and 1895 Lautrec
painted over fifty works depicting brothel life or using
the girls as models, as well as many scribbled pencil
sketches or frivolously comic, erotic jottings. But his

time in these years was not solely consumed by the
world of prostitution; in 1894, the same year that he
painted the large and ambitious *Salon at the rue des
Moulins* (Plate VI), he also published the 'French
Series' of lithographs of Yvette Guilbert. Making ex-
tended visits to the brothels over a number of days was
Lautrec's custom, rather than living in them, and his
time was used industriously. According to Coolus, a
crony of Lautrec at this time, the artist had a private
room in the rue des Moulins establishment which he
used as a studio, only going into the salon in the even-
ings. These are professional conditions which modify
motives both personal and artistic. Evidently Lautrec's
attraction to the brothel and its inmates was instigated
by his own appetites and also by his love to shock; one
anecdote recounts that he invited Durand-Ruel, the
influential but stuffy art dealer, to discuss business in
one of the *maisons closes*. The brothel also continued
Lautrec's fascination with women. He did not see it as a
masculine pastime, as had Forain, but as a parade, in
the brothel's quieter moments, of varied aspects of a
marginal, feminine world. This opportunity for obser-
vation was central to Lautrec's rationale; the brothel
allowed him a simultaneous combination of the nude,
or, more often, semi-nude figure and a subject matter.
A remark of his, made about these paintings, was
remembered by Yvette Guilbert, 'Everywhere and
always, ugliness has its beautiful aspects; it is thrilling
to discover them where nobody else has noticed them.'
This remark bundled together an aesthetic and a
patent of novelty. The very regularity of. Lautrec's
work in brothels, combined with the group identity of
the paintings made from subjects found there, suggests
the seriousness and the novelty that he saw in the work.
Lautrec depicted brothel subjects in two ways, either
the portrait or figure study of the lone prostitute, or
the vignette of day-to-day existence, bed-making, per-
haps, or waiting for clients. Pictures of the first type
succeed, or not, on their own terms—a good portrait, a
bad sketch—and they are the informal notations which

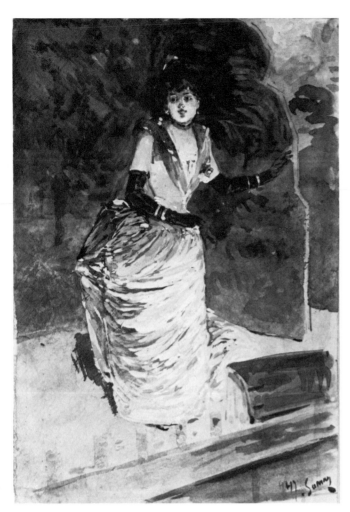

fig. 16 Henry SOMM
Yvette Guilbert Singing
Williamstown, Sterling and Francine Clark Art
Institute. c. 1885–90. Gouache 20·9 × 14 cm.

Somm (1844–1907), whose real name was
François-Clement Sommier, won considerable
popularity in the 1880s and 1890s for his
illustrations and caricatures in newspapers such
as *Le Chat noir*, *La Cravache* and *Frou-Frou*.
Perhaps best known now for his little water-
colours of women in fashionable clothes, Somm
also designed menus and theatre programmes.
He was the subject of one of Lautrec's rare
dry-point portraits, made in 1898 (Adhémar
281).

fig. 17 Théophile-Alexandre STEINLEN
'Ambassadeurs': Yvette Guilbert Tous les Soirs
London, Victoria and Albert Museum. 1894.
Colour lithograph 180·9 × 78·7 cm.

The work of Steinlen (1859–1923) was com-
mon in periodicals like *Le Chat noir*, *Le
Mirliton* and *Le Rire* throughout Lautrec's
working life. Steinlen's illustrations concen-
trated on the social issues that Lautrec tended
to avoid, but their careers overlapped at
points. Both illustrated Bruant's songs and
exhibited at his Mirliton cabaret, for example.
Steinlen often portrayed Yvette Guilbert, and
the diseuse preferred this more flattering poster
to the one started by Lautrec at the same
period (Plate 53).

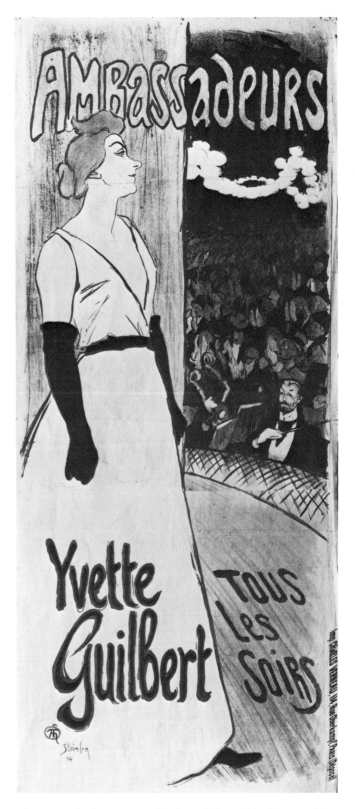

often caught Lautrec at his best (Plate 60). Those of the
second type, in which Lautrec was often obliged to show
figures in combination, have an inconsistency that may
reveal 'beautiful aspects' or fall into caricature. The care
taken over the *Medical Inspection* (Plate 46) suggests
that the painting mattered to Lautrec, the drawing of
the faces that the plight of these women really affected
him. And yet *The Laundryman* (Plate 45) falls back on a
less sensitive and more satirical reliance on 'type', on
mask-like physiognomies, or alternatively on the smutty

aside; the leer on the laundryman's face could be explained if the absent-minded *fille* checking the laundry list has left open her *peignoir*. It is as if the qualities of observation that Lautrec possessed, so well attuned to oil sketches and studies of individual pose or expression, could not be easily reconciled in a painting that would successfully combine the personal and incisive record of his glance and the more complex possibilities of an art with narrative, anecdotal requirements, a sense of place, a unity of activity or mood, an equality of treatment in the figures.

The only paintings in which Lautrec frequently and successfully balanced these qualities, and the only ones in which he depicted physical union, were those in which he showed lesbian affection. According to Thadée Natanson, Lautrec was fascinated by sexual extremes, as he was by graffiti. But with his lesbian scenes the painter produced some of his most direct, accurate and sensitive accounts of the relationship between a couple, by a combination of pose and facial expression rare in his *oeuvre*. The very care that went into these works and the fact that lesbianism continued to interest Lautrec in his print-making after the brothel period was terminated with the *Elles* album of lithographs (1896) (Plates 62 and 64) indicate the depth and seriousness that he found in this theme. The lesbian paintings work on several levels: as an opportunity to fuse the posing of reclining female models with a specific descriptive content not without a certain sensual frisson; as a westernization of the erotic Japanese print; and as a serious psychological moment which Lautrec could handle from a sympathetic distance because he was, prima facie, excluded.

At this point the perennial question of the moral nature of Lautrec's work arises. He himself did what he could to evade the issue. On the one hand he refused to exhibit his brothel subjects in public and at the 1896 one-man show they were hung in a locked room into which the painter ushered only his closest friends. Yet on the other the work was greedily undertaken. Lautrec painted few crudely lascivious pictures. Those that he did paint, or have survived his own or other censorships, are not pictures of quality but lapses into a bawdiness that have none of his perceptive qualities; this is true of, for instance, *On the Stairs at the rue des Moulins* (private collection, 1893), a *fille* crawling upwards, her naked buttocks thrust clumsily at the spectator. Lautrec's few overtly pornographic offerings, mostly drawings, are no more than scatological or erotic pranks and were kept in the studio. Yet from the outset of his exhibiting career Lautrec's work was praised or execrated very largely on the critics' attitude to his subjects and the moral impression that the writer supposed they gave. He was attacked fervently on such grounds as 'the depravity of the soul', especially so when given a one-man show in Victorian London in 1898. Writing in the following year one opponent, Alexandre Hepp of *Le Journal*, vituperated, 'What a need to suspect, to slander, to degrade everything, or rather what a delight in persecution!' But some admired Lautrec's work for the revelations of humanity that could be perceived behind his fierce cathartic images. In 1893 Gustave Geffroy, an excellent critic writing for *La Justice*, coined a brilliant summary of Lautrec's art in his phrase 'human landscapes' ('paysages d'êtres') and continued that 'the philosophy of vice that Lautrec proposes from time to time in his challenging way is like a clinical demonstration in the field of morals, such is the power of his drawing and the seriousness of his diagnosis.' A few months later the anarchist weekly *Le Père Peinard* gave more graphic agreement with its own rollicking critique. 'The one who's got the biggest cheek of all is Lautrec, that's for certain. No nonsense about his colours or drawing—just great solid patches of white, black and red, that's him. He's on his own as a painter of sugar-daddies out on a spree with tarts drooling over them . . . He's as tough, cheeky and bitchy as you like, and it's a revelation for the softies who think painting ought to be just like sugar-candy.' It is doubtful whether the artist, whose depiction of vice was inspired in the first instance by his own enjoyment of it, be it brothel or bottle, would have agreed with Lepelletier's accusation of 'pursuing the ideal amid the most sordid realities' or whether Lautrec, whose politics were right-wing, would have welcomed his sudden status as persona grata of anarchism. Geffroy, of course, was correct in indicating that themes from the world of vice were not Lautrec's only ones, but there remain works that are inescapably redolent of sexual or alcoholic extremes. It is surely insufficient to say that Lautrec's moral content lies in his objectivity, a definition itself insufficient to describe the careful paintings of lesbian couples, 'as tender as birds' said the artist, or the seemingly deliberate viciousness of *At 'La Mie'* (Plate 23). This painting was posed by Guibert, a notorious *débauché*, and an unknown woman, then photographed by Sescau to help Lautrec's memory, a step that might suggest that the painter was concerned to make this picture one of some importance. Like most of the paintings in which Lautrec has contrived to bring out a human drama *At 'La Mie'* is rather weak, the lewd fatuity of the sodden man captured with more perceptive observation than the woman's clumsy, squinting face. Such an outright effort at a 'moral' scene was not Lautrec's forte. Summarizing character was essential to his art and is, after all, the mainspring of his attention to actors and performers, yet Lautrec did this best when he was not trying to force his subject to carry more narrative overtones than it could bear. He did not, however, remain objective, removed from his subjects or sitters; temperament denied that. Lautrec's nature, his acute wit, depth of insight and opinionated

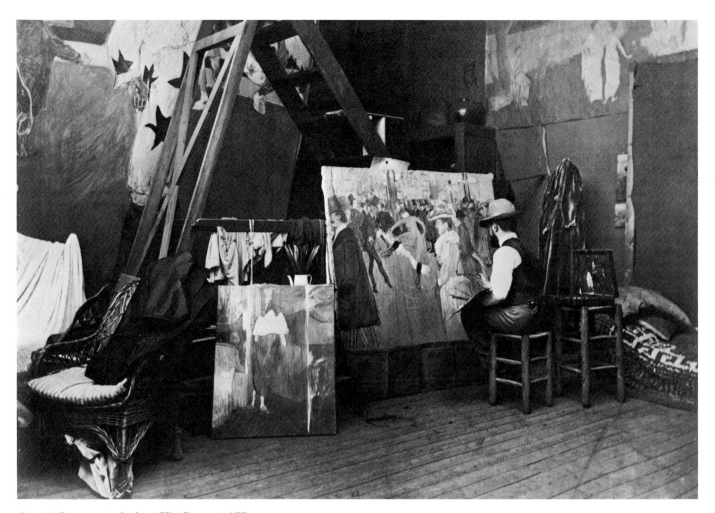

fig. 18 Lautrec painting *The Dance at 'The Moulin Rouge'* (Plate 22), 1890. The *Parody of 'Le Bois Sacré' by Puvis de Chavannes* (Plate 10) hangs on the right.

confidence combined with his artistic means of descriptive line, emotive colour and blatant presentation to produce a human art that is psychologically interpretative but not overtly moralistic.

Lautrec's art began to falter after about 1896, after the successes of *Chilpéric* and *Elles* (Plate 62). His health, failing in the face of obsessive alcoholism and worsening syphilitic symptoms, was the cause of this professional decline. His control, behaviour, and health deteriorated together. In 1897, while staying with the Natansons at Villeneuve-sur-Yonne, he had hallucinations and fired a pistol at giant, imaginary spiders. Before Lautrec's brief internment in a private nursing home in the spring of 1899, the occasion that aroused the spiteful curiosity of the Paris gossip columns, he had been on a course of steady decline. There are many instances of his gradual meanderings towards self-immolation, the most vivid of which are the letters written in early 1899 to the comtesse by Berthe Sarrazin, the maid left in Paris to look after Lautrec. These letters recount the most pathetic behaviour of the baffled drunk, telling of Lautrec spending hundreds of francs on buying dolls and useless trinkets, burning

newspapers in the lavatory bowl. After Lautrec's cure at the home in Neuilly he rallied his self-control briefly, but his habits were too powerful for this to last, his physique too battered to withstand a return to the bottle. By the Exposition Universelle of 1900 he was touring the pavilions in a wheelchair; he managed a last burst of work in the winter of 1900–01 while staying in Bordeaux, and in high summer paralysis struck while he was by the sea at Taussat. Lautrec was taken home to Malromé, where he died a few days later, on 9 September 1901.

Thus the last four years of the artist's life were lived in a maze of debauchery, incapacity and ill health. Inevitably, this affected Lautrec's work. Most obviously there was a quantitative lapse; there were some thirty-five paintings in 1888 but only nineteen in 1897, fifty for 1894 but a mere twenty for 1899. Lautrec had concentrated less and less on painting, but even his lithographs fell off in number, if not to such a degree. Since 1894, when he had hit his stride, Lautrec had sustained a regular annual output of some fifty prints, producing half as many again in the *annus mirabilis* of 1895. In the last three years, from 1899, he failed to reach fifty all

told. Lautrec's faltering health led to uneven production and uncompleted projects. The magnificent illustrations for Jules Renard's *Histoires naturelles* were begun as early as 1896, but, because of Lautrec's postponements, the book was not published until early 1899, the year a projected album of race-course lithographs (Plate 75) failed to materialize. The lithographic work of Lautrec's last four years developed in two particular directions. On the one hand there are prints (Plate 71) which show that he was taking the medium less seriously than in the past, that it was being used informally for the dissemination of mere sketches or inferior ideas; indeed, a couple of such lithographic ramblings, with pipe-smoking parrot and dog in spurs, are frequently used as evidence of the artist's state of psychic disturbance in early 1899. In the more serious works, on the other hand, Lautrec worked the lithographic crayon in a newly developed way to depict the subjects, still mainly actors and entertainers, who had caught his eye. *The Chestnut-vendor* (Plate 72) of 1897 is an instance of this development; the fiercer hatching and heavier tones of such prints corresponding with the less linear style that Lautrec was simultaneously exploring in his painting.

There is controversy over the later paintings, such as *Messaline* (Plate 77), as to whether they are interesting aberrations or works of quality in their own right, whether they are symptomatic of a declining talent or one in transition. The internal evidence of a number of works suggests that Lautrec was moving towards a new approach to the painted image. His manner of applying paint in long strokes that evoked volume with line as the brush distributed colour had been developed in the late 1880s; a decade later its defects would have become clearer to Lautrec, its qualities perhaps over-familiar. A number of threads must be woven together to understand the possible reasons behind Lautrec's new inclinations in his painted work. By the mid-1890s his good reputation was largely based on his posters—he had been fêted as a master of the medium in two books by 1896—whereas he had begun his career with a succession of large 'machines' intended to establish himself as a painter. He may have felt this balance needed redress. Lautrec's characteristic manner of painting had evolved from the need for a rapid method to express the fleeting, for which end he now had lithography, the very medium which, being inescapably tonal, might have aroused the artist's interest in a measured and tonal method of painting. Broad areas of subdued colour, as in *Au 'Rat Mort'* (Plate 76) could be more easily organized than the loose, separate strokes of the earlier work into a paint surface that animated the *whole* canvas, and not just the selected areas on which Lautrec had previously concentrated. And a renunciation of his linear and gestural emphasis for more methodical touches and overall control would permit a play of light which

Lautrec had rather tended to ignore. Notably from about 1895 Bonnard, with whom Lautrec had contact, was changing from his early style to a looser, more fluctuating handling of paint that gave itself more to an awareness of light.

The pictorial evidence for Lautrec's restlessness can be traced at least to 1896, when he painted a new series of 'impositions', much as he had in Forest's garden some seven years before. This second group is not so numerous and concentrates on the nude rather than the portrait. In the best of these nudes, *La Toilette* (Plate 69), Lautrec returned to the germinal example of Degas, for a disciplined approach to more naturalistic, even more sculptural, practices. By 1899, in *The English Girl from 'The Star'* (Plate 74), Lautrec was still searching for an adequate handling of paint to cope with the 'total' area of the canvas. The exploratory character of his painting at this time should not detract from this particular jewelled, jovial work, but it remains an isolated, unechoed solution to the more tightened discipline he wished to impose upon his work. In *The English Girl* Lautrec rejected the profile he had chosen in a preparatory drawing, perhaps because of its temptation towards flattening, and turned the head slightly towards the spectator, so forcing on himself a more solid motif. The paint was built up in small touches rather than in long lines, in such a way that this canvas is almost a rapprochement with the portrait of his mother (Plate I) painted eighteen years before. Lautrec's sense of volume was never a strong feature of his work. So in his last paintings, where the line is denied its previous rôle, the modelling is at times wanting in its ability to suggest volume; in the Courtauld *Au 'Rat Mort'* (Plate 76), for example, Lautrec seems to have been unable to sustain a robustness, the courtesan's face having a firmer mass than her gloved hand or the man's half-seen head. *Au 'Rat Mort'*, however, succeeds in the same way as other paintings from the final period, such as *The Milliner* (Plate IX), because the technique seems perfectly attuned to the rather vicious mood Lautrec now imposed on his usual imagery. Angular drawing, sharp accents of light, sullen complementaries of colour all combine in a vision that echoes so well the last hours of a life that fierce living was bringing to a close.

There is nothing finite about the art of Lautrec. In its passing enthusiasms and progress from the low to the sophisticated, its adoption of the unfinished, and its loping, halting, yet quite appropriate brushwork, it makes for itself a mobile character. To pass through Lautrec's images and to put them together is to compile a flexible anthology of scenes and types, a particular period, a particular Paris. When he attempted the definitive summation of a theme, and this happened rarely, he became over-encumbered by the prospect. *The Salon at the rue des Moulins* (Plate VI) is the best

instance, the pallid and slack surfaces never rallying with the tightness of design. Yet there are moments when Lautrec's pictures arrive at a genuinely lasting and potent imagery, as in *The Milliner* (Plate IX), plying the expressionistic passage between Goya and Kirchner. He has none of the analytic fixity of a Seurat or the thriving complexity of a Degas. Lautrec's is a partial art; partial in its choices, its compositional concentrations, and its unwillingness to make single, total statements. His work followed a clear enough pattern. After studying in the ateliers he investigated both popular and avant-garde possibilities, and then from 1888 to 1892 he produced a number of large figure pieces that used Degas's involved formulary for composing the city crowd. He then more or less dropped the ambitious for the single and the immediate—smaller paintings and scenes, portraits and figure studies,

lithographs. He no longer made large pictorial reconstructions of music-hall crowds, but moved on to smaller assessments of performers, actors and characters with a direct positing of the image. This is paralleled by the shifting social and cultural axes of his surroundings, from The Butte to the boulevards, from Montmartre to *La Revue blanche*. Lautrec achieves his stature as an image-maker not so much from single works, beautiful and strong as some may be, but rather from the sequential power of his work. The meaning of Lautrec's art lies in his consistent choice to court the ephemeral, to exist in dalliance with it, either the poster for a short season or the fly-by-night performer, the *fille de joie* or menu card, all treated with the brushwork of instinctive casualness. His art balanced on the same brink as his life.

fig. 19 Lautrec in the atelier, c. 1894. The paintings include *The Salon at the rue des Moulins* (Plate VI) in the centre, *Monsieur, Madame and the Dog* (Plate 42) beneath its left-hand corner and *Alfred la Guigne* (Plate 44) beneath its right.

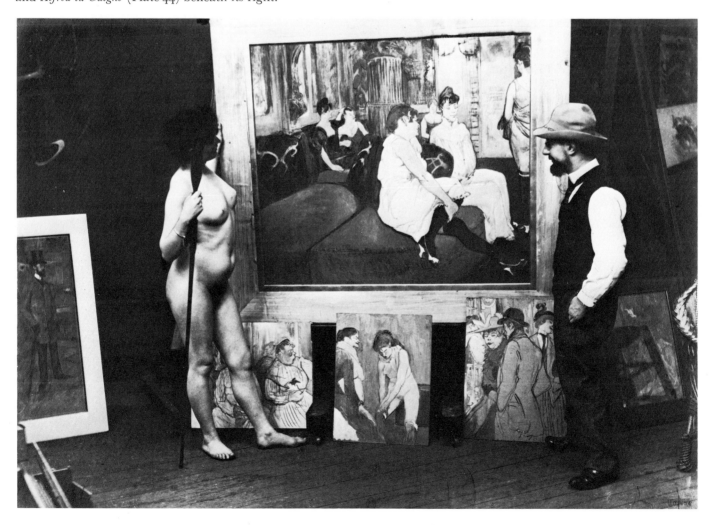

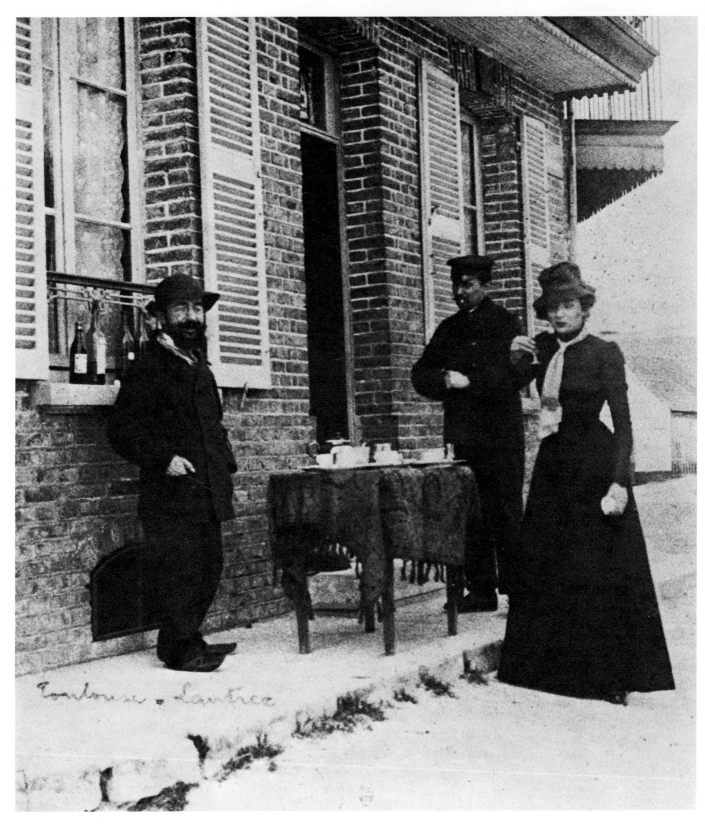

fig. 20 Lautrec with friends, c. 1899.

Chronology

1864 Henri Marie Raymond de Toulouse-Lautrec-Monfa born (24 November) in Albi, son of Comte Alphonse de Toulouse-Lautrec (1838–1913) and Adèle Tapié de Céleyran (1841–1930), first cousins.

1867 Birth of brother Richard (died 1868).

1872 Family moved to Paris; Lautrec entered Lycée Fontanes, later Lycée Condorcet; met Maurice Joyant (1864–1930).

1875 Returned to Albi; educated by the comtesse and tutors.

1878 Fractured left leg (May).

1879 Fractured right leg (August).

1881 Failed (July), then passed (November) baccalauréat; illustrated *Cahiers de Zig-Zags*, a pictorial account of his visits to spas and resorts, for a cousin.

1882 Studied with Princeteau; joined Bonnat's atelier (March); switched to Cormon's studio (September); at Cormon's during the next few years met Gauzi, Rachou, Emile Bernard, van Gogh, Louis Anquetin, René Grenier.

1883 Rented own studio (December); family tension over this followed.

1884 Lived with Grenier, 19 rue Fontaine (summer); Degas's studio in same building; worked less at Cormon's atelier.

1885 Began to frequent Bruant's Le Mirliton; visited Anquetin in Normandy; painted murals at Auberge Ancelin, Villiers-sur-Morin (winter).

1886 Work displayed at Mirliton; Lautrec took studio at 7 rue Tourlaque, on corner with rue Caulaincourt (kept this until 1897); Gauzi and Zandomeneghi had studios there.

1887 Rented flat with Doctor Bourges at 19 rue Fontaine; spent summer at Arcachon; visited by van Rysselberghe.

1888 Exhibited eleven paintings and a drawing at Les XX, Brussels (February).

1889 Spent summer at Arcachon; exhibited at Exposition du Cercle Artistique et Littéraire, rue Volney (June) and Salon des Indépendants (October).

1890 Joyant succeeded Théo van Gogh in charge of Goupil Gallery; Lautrec visited Brussels (January); exhibited at Les XX (January) and Salon des Indépendants (March).

1891 Argued with Roques of *Le Courrier Français* (April); cousin Gabriel Tapié de Céleyran arrived in Paris to study medicine; on advice of Bonnard and printer Ancourt Lautrec took up lithography; exhibited at Cercle Volney (February) and Salon des Indépendants (April).

1892 Began to work on *maisons closes* subjects; decorated salon of rue d'Amboise brothel; visited London (May–June); exhibited at Les XX (January), Salon des Indépendants (March), Cercle Volney (April) and with Le Barc de Boutteville (December).

1893 Bourges married (July); Lautrec moved in with the comtesse at rue de Douai; began work for *L'Escarmouche* and *La Revue blanche*; illustrated songs of Maurice Donnay; exhibited at Les XX (February), Salon des Indépendants (April) and Les Peintres-Graveurs Français (May); in February had his first one-man show at Boussod-Valadon, a subsidiary of Goupil's, shared with Charles Maurin, organized by Joyant.

1894 Moved to flat at 27 rue Caulaincourt (January); visited Belgium, Holland (February) and London (June); asked to work for *Le Rire*; publication of 'French' series of Yvette Guilbert lithographs; Lautrec executed stage decorations for *Le chariot de terre cuite*; exhibited at La Libre Esthétique, the organization that superseded Les XX (February), Salon des Indépendants (May) and La Dépêche de Toulouse (May); lithographs shown at Durand-Ruel's (May) and posters at the Royal Aquarium, London (October).

1895 Lautrec visited Brussels (April) and London (May), where he met Wilde, Whistler; stayed with Natansons at Valvins (July); impulsive trip to Portugal and Spain with Guibert, in search of an unknown woman (August); Lautrec exhibited at La Libre Esthétique, Salon des Indépendants, Salon de la Société Nationale des Beaux-Arts, Centenaire de la Lithographie and Royal Aquarium, London (all April) and at Salon des Cent (October).

1896 Lautrec in Bordeaux and Arcachon (January–February); went to Brussels with Joyant (February); met van de Velde; was fascinated by Arton and Lebaudy trial (March–April); spent spring with Natansons at Villeneuve-sur-Yonne; went to London (June) and then Holland (June–July); had a long visit to Spain (August) and a trip down Loire (November); illustrated Coolus's *Les soeurs légendaires*; had an important one-man show at Manzi-Joyant Gallery, 9 rue Forest (January); exhibited at La Libre Esthétique (February), Salon des Cent (April), where he showed the *Elles* series and Exposition Internationale de l'Affiche, Rheims (November).

1897 Left rue Tourlaque studio for one at 15 rue Frochot (May); visited London (July) and Villeneuve-sur-Yonne (summer); exhibited at La Libre Esthétique (February) and Salon des Indépendants (April).

1898 Experimented with dry-point (January-February); illustrations for Clemenceau's *Au pied du Sinaï* published (April); Lautrec visited London (May); 'English' series of Yvette Guilbert lithographs published (May); Lautrec went to Arromanches (July) and Villeneuve-sur-Yonne (September), where he was painted by Vuillard; exhibited seventy-eight works at Goupil Gallery, Regent Street, London (May); work shown at own atelier, rue Frochot (April).

1899 Publication of Jules Renard's *Histoires naturelles* (January); Lautrec interned at Dr. Sémelaigne's clinic, Neuilly (February–May); travelled during summer; in Le Havre (July); Lautrec served as a member of jury for poster section of Exposition Universelle, 1900 (October).

1900 Spent summer on Biscay coast with Viaud but in Bordeaux by December; exhibited at Exposition Universelle and organized show of work next door to atelier (May).

1901 Lautrec in Bordeaux and Malromé (January–April) but went to Paris (April) in order to sort out paintings and belongings; Lautrec's health finally failed at Taussat (August); he returned to Malromé and died (9 September).

Bibliography

The essential work for the study of Lautrec is the catalogue raisonné by Mme. M.-G. Dortu, *Toulouse-Lautrec et son oeuvre*, 6 vols. (New York 1971). This contains all the paintings and drawings and is based on Maurice Joyant's pioneering *Henri de Toulouse-Lautrec*, 2 vols. (Paris 1926–27). The Joyant volumes represent the first attempt to list Lautrec's productions in all media, and the text remains the most valuable repository of trustworthy information about the artist. Jean Adhémar's *Toulouse-Lautrec, His Complete Lithographs and Drypoints* (London 1965), cited in this text as Adhémar, has superseded the catalogue of printed work on which it, in turn, is founded, Löys Delteil's *Le peintre-graveur illustré: Henri de Toulouse-Lautrec*, vols. X and XI (Paris 1920).

Witness Accounts

Achille Astre, *H. de Toulouse-Lautrec* (Paris 1926).

François Gauzi, *Lautrec et son temps* (Paris 1954).

Paul Leclercq, *Autour de Toulouse-Lautrec* (Paris 1921; Geneva 1954).

Thadée Natanson, *Un Henri de Toulouse-Lautrec* (Geneva 1951).

William Rothenstein, *Men and Memories* (London 1931).

Arthur Symons, *From Toulouse-Lautrec to Rodin* (London 1929).

Mary Tapié de Céleyran, *Notre oncle Lautrec* (Geneva 1956).

General Studies

Jean Adhémar and Francis Jourdain, *Toulouse-Lautrec* (Paris 1952).

Douglas Cooper, *Toulouse-Lautrec* (London 1955).

Gustave Coquiot, *Toulouse-Lautrec* (Paris 1913).

M.-G. Dortu and Philippe Huisman, *Lautrec by Lautrec* (London 1964).

André Fermigier, *Toulouse-Lautrec* (London 1969).

Gerstle Mack, *Toulouse-Lautrec* (New York 1938).

Fritz Novotny, *Toulouse-Lautrec* (London 1970).

Henri Perruchot, *La vie de Toulouse-Lautrec* (Paris 1958).

Specific Topics

Daniel Catton-Rich, *'Au Moulin Rouge': Toulouse-Lautrec* (London n.d.).

Michel Georges-Michel, 'Lautrec et ses modèles', *Gazette des Beaux-Arts*, vol. LXXIX (April 1972).

Lucien Goldschmidt and Herbert Schimmel (eds.), *Unpublished Correspondence of Henri de Toulouse-Lautrec* (London 1969). Introduction and notes by Jean Adhémar and Theodore Reff.

Edouard Julien, *Les affiches de Toulouse-Lautrec* (Monte Carlo and Paris 1951).

Benedict Nicolson, 'Notes on Henri de Toulouse-Lautrec', *The Burlington Magazine,* vol. XCIII (September 1951).

Fritz Novotny, 'Drawings of Yvette Guilbert by Toulouse-Lautrec', *The Burlington Magazine,* vol. XCI (June 1949).

Hervé Oursel, 'Un tableau de Toulouse-Lautrec', *La Revue du Louvre,* vol. 4 (1975).

(opposite)
I *The Comtesse Adèle de Toulouse-Lautrec*
ALBI, Musée Toulouse-Lautrec. 1881. Oil on canvas 92 × 80 cm. Monogram bottom left.

Lautrec made a series of portraits of his mother in the 1880s, both painted and drawn. There is some dispute over the dating of this portrait, Dortu and the Musée Toulouse-Lautrec catalogue accepting 1881. Julien has suggested 1883 as the terminus post quem on the assumption that the setting is the château at Malromé, which the comtesse did not buy until that year. This later date is possibly supported by the sophistication of the handling; the painting's apparent, and frequently exaggerated, closeness to Manet or to Berthe Morisot perhaps suggests a knowledge of advanced trends in Paris. However, the tendency to *peinture claire,* high-keyed transparent colour, displayed in this picture was an established current with contemporary mainstream artists, such as Bastien-Lepage or Princeteau, and Lautrec was evidently aware of this before he settled in the capital.

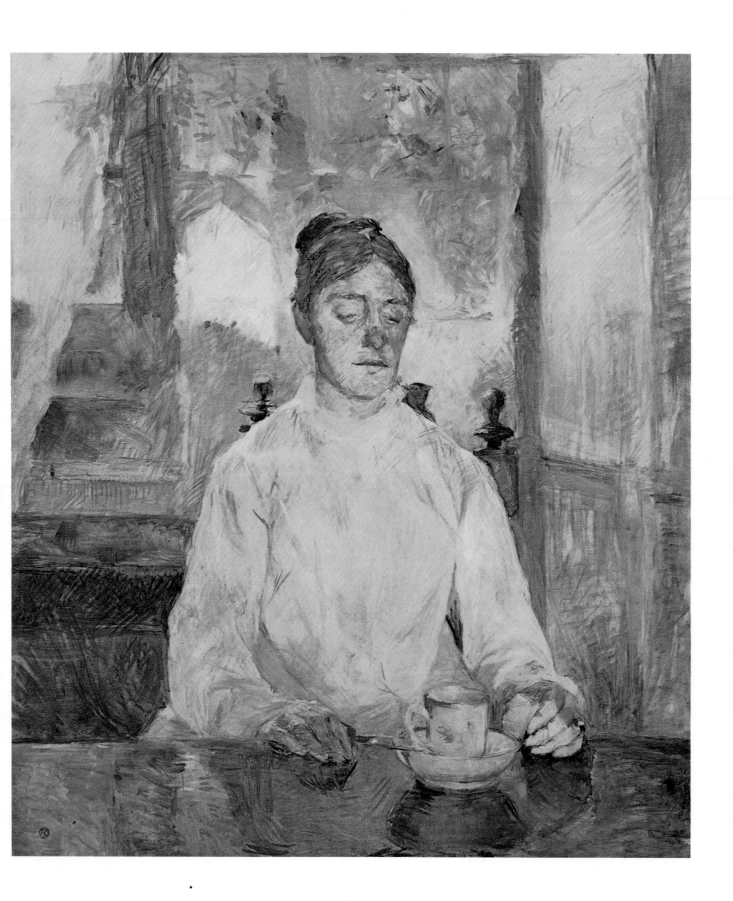

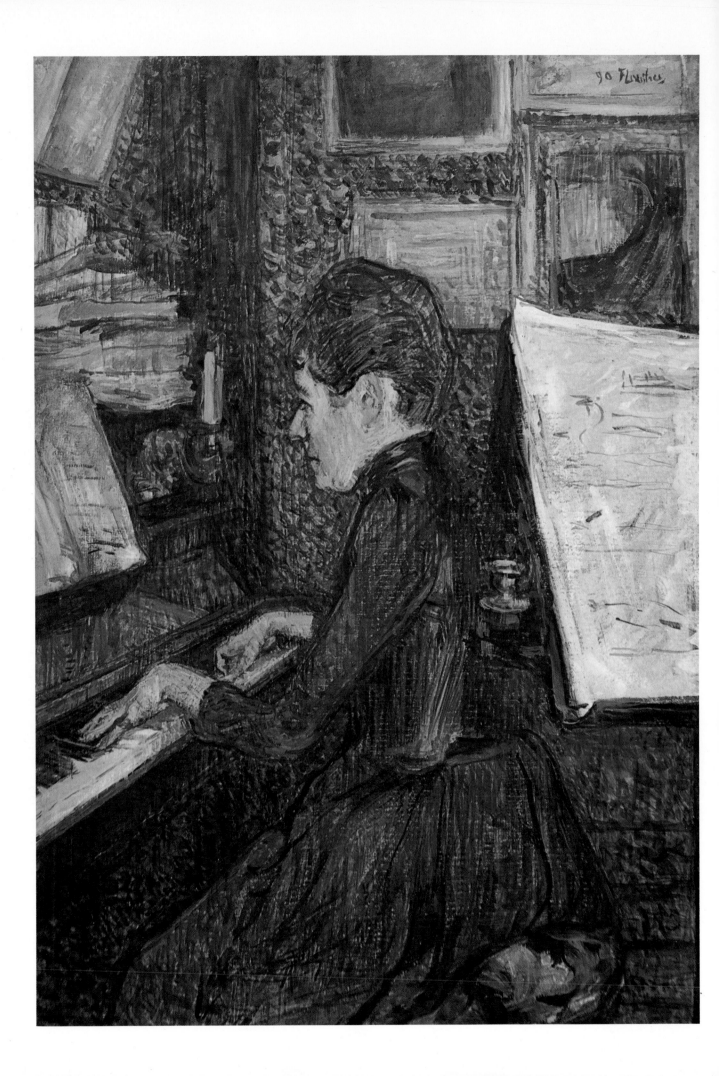

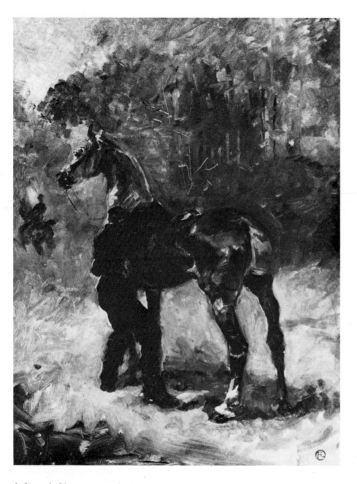 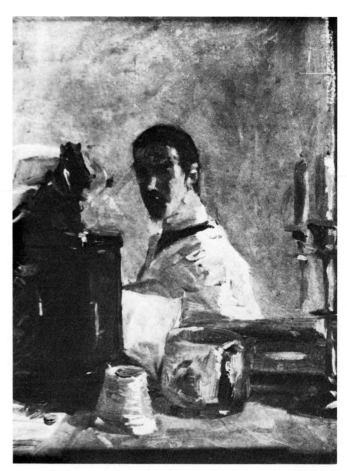

(*above left*)
1 *Artilleryman Saddling his Horse*
ALBI, Musée Toulouse-Lautrec. 1879. Oil on canvas 50·5 × 37·5 cm. Monograms bottom left and bottom right.

One of several paintings which record the military manoeuvres Lautrec had seen at Le Bosc, the *Artilleryman* is a straightforward study of movement. Already there is a variety of touch, notably lines scratched into the paint to indicate the trees, remarkable for a fourteen- or fifteen-year-old.

(*above right*)
2 *Self-portrait at Sixteen*
ALBI, Musée Toulouse-Lautrec. 1880. Oil on board 40·5 × 32·5 cm. Unsigned.

This is Lautrec's only self-portrait in oil, if his occasional appearances in group scenes (Plates 33 and V) are discounted.

(*opposite*)
II *Marie Dihau at the Piano*
ALBI, Musée Toulouse-Lautrec. 1890. Oil on cardboard 63 × 48 cm. Signed and dated top right.

Marie Dihau lived with her brothers Désiré and Henri in the rue Frochot. All three were musicians, friends of Lautrec's family and of Degas. Lautrec also painted portraits of the brothers; the Musée Toulouse-Lautrec owns one of Henri and two of Désiré, all painted in Père Forest's garden in 1891. Désiré, like Lautrec, worked at both ends of his professional spectrum; a bassoonist at the Opéra, he also wrote songs for the repertoire of The Chat Noir. Lautrec lithographed several cover illustrations for the sheet-music of these songs. About 1869 Degas had painted portraits of Désiré in the Opéra orchestra and of Marie at the piano (both in the Musée du Jeu de Paume, Paris), and Vuillard, for one, remembered how much Lautrec had admired these. Degas's portrayal of Marie was included by Lautrec behind the music-stand in his own portrait of Mlle. Dihau, which was exhibited at the Salon des Indépendants of 1890. It has been remarked that the Dihaus secured Lautrec's introduction to Degas, although there have been other suggestions, Arsène Alexandre, for instance, citing Joseph Albert as responsible for the meeting. Many of Lautrec's friends in the 1880s knew Degas as fellow-painters or as models, John Lewis-Brown, Forain, Zandomeneghi, Suzanne Valadon, Lili Grenier, so the two were almost bound to meet. The complex question of Degas's appreciation of Lautrec's work remains. It is simplest and safest to say that Degas had a respect for Lautrec; this is the evidence of Joyant, a generally trustworthy witness, and finds corroboration in independent recollections, such as those of Rothenstein.

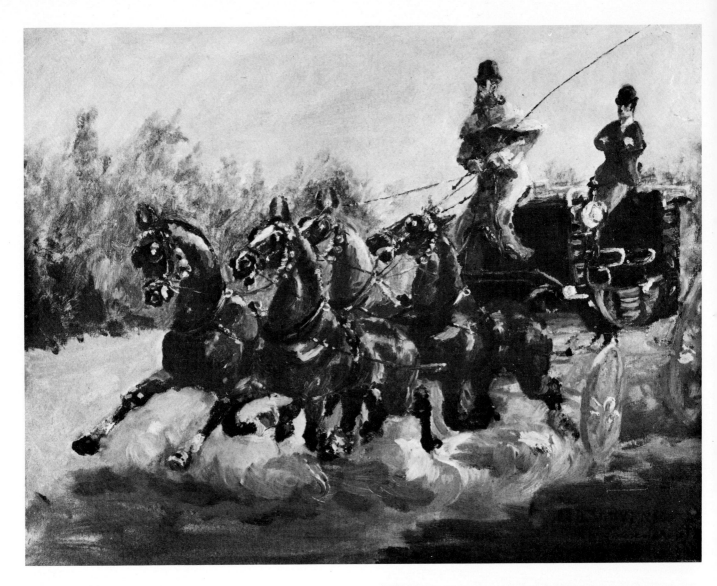

3 *The Mail Coach, a Four-in-Hand*
PARIS, Musée du Petit Palais. 1881. Oil on canvas
39 × 50 cm. Signed.

The coach is driven by Comte Alphonse de Toulouse-
Lautrec. Painted on the Riviera during Lautrec's visit in
the early months of the year, the canvas is signed:
'H.T.L.—SOUVENIR de la promenade des Anglais,
Nice 1881'. As in many other paintings of this period, the
influence of Princeteau is apparent. In May of 1881
Lautrec's mother reported that he was copying one of
Princeteau's works.

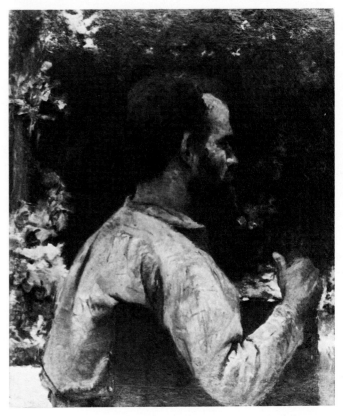

4 *Head of a Man: Etienne Devisme*
ALBI, Musée Toulouse-Lautrec. 1881. Oil on canvas
61 × 50 cm. Unsigned.

This portrait is a good example of Lautrec's adoption of
larger canvases and correspondingly larger brushstrokes as
his oil painting became more ambitious. The pose, with
the sitter almost seen from behind, was used again in some
of the portrait 'impositions' done years later in Paris, for
example *Désiré Dihau Reading a Paper* (Albi, Musée
Toulouse-Lautrec, 1891). Devisme was a friend whom
Lautrec had first met at Barêges in 1878; he was older
and also an invalid. In 1881 Lautrec drew illustrations for
Devisme's rather feeble novel *Cocotte*.

(*above left*)
5 *Nude Seated on a Divan*
ALBI, Musée Toulouse-Lautrec. 1882. Oil on canvas 55 × 46 cm. Unsigned.

It is probable that this study was painted at the outset of Lautrec's studio work in Paris. Not yet as dark as the later paintings executed under Bonnat and Cormon, it has a sharpness of line, a smoother facture and a broader handling of planes than his earlier figures. The pose, with its carefully balanced angling of torso and limbs, is more tutored than in the informal figures of earlier years.

(*above right*)
6 *Life Drawing*
ALBI, Musée Toulouse-Lautrec. c. 1881–83. Pencil and charcoal 61 × 47 cm. Unsigned.

Testifying to Lautrec's hard work while a student in Paris are the vast number of drawings from the life-model that have survived. In these practice works he seems to have made a deliberate effort to discipline his drawing, responding to Bonnat's demands.

(*above left*)
7 *An Allegory: the Abduction*
ALBI, Musée Toulouse-Lautrec. 1883. Oil on canvas 72·8 × 53·8 cm. Unsigned.

Lautrec made only a few attempts at the mythological subjects that were expected from the pupils of the teaching ateliers. This painting shows an effort to instil the fading genre with energy, using his expertise with the physique of the horse.

(*above right*)
8 *Composition*
ALBI, Musée Toulouse-Lautrec. 1883. Charcoal on blue paper 62 × 47 cm. Monogram bottom left.

Three nymphs in a pool are approached by a knight on horseback in this rare 'history' picture from Lautrec's student period. Both the subject and the modelling from light to dark relate this large drawing to the lithographs of Fantin-Latour, especially his prints illustrating musical themes, and to Cormon's illustrations for Victor Hugo's *La légende des siècles,* on which he had asked Lautrec to collaborate in 1884.

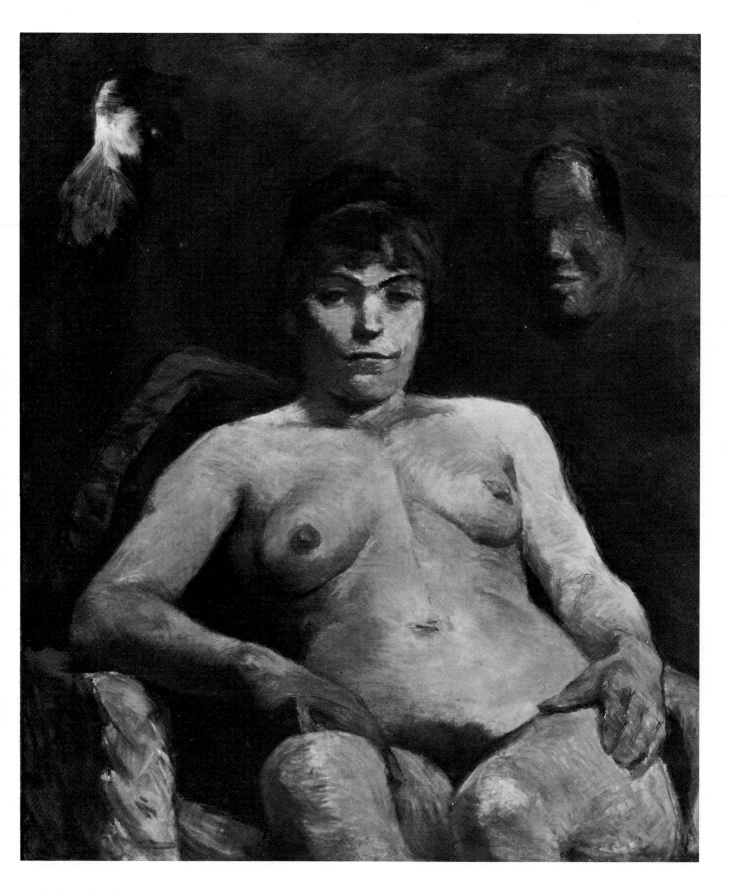

9 *La Grosse Maria*
WUPPERTAL, Von der Heydt Museum. 1884. Oil on canvas 79 × 64 cm. Unsigned.

Joyant entitled this canvas *The Venus of Montmartre,* indicating that the woman was a prostitute and identifying the painting as one of Lautrec's first ventures into such subject matter. However, the adventurous foreshortening and firm modelling hint that, despite the masks added to localize the sitter, she was merely a model, a vehicle for a technical exercise on which an iconography has been imposed. *La Grosse Maria,* like the portraits of Carmen painted in 1885, shows how Lautrec's palette had darkened under the supervision of Bonnat and Cormon.

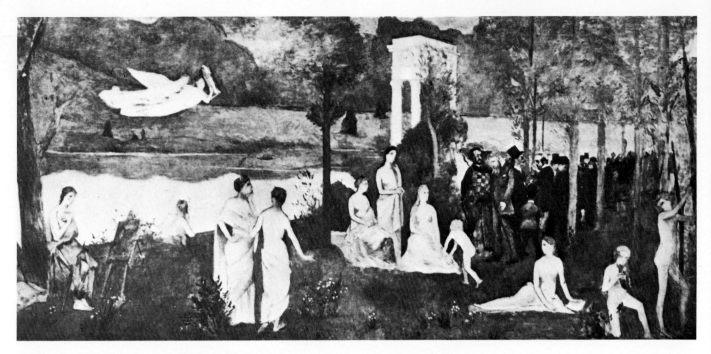

10 *Parody of 'Le Bois Sacré' by Puvis de Chavannes*
NEW YORK, estate of Henry Pearlman. 1884. Oil on canvas 172 × 380 cm. Unsigned.

Puvis de Chavannes was highly respected by both conservatives and the avant-garde for his serious and harmonious allegorical works. *Le Bois Sacré cher aux Arts et aux Muses* achieved a great success at the Salon of 1884, firmly establishing the esteem in which Puvis was held until his death in 1898. Here Puvis, known to Lautrec's circle as 'Pubis de Cheval', became the butt of rumbustious student humour. This large canvas seems to have been the work of a number of Lautrec's friends, for he told Gauzi that it had been executed in two afternoons, a feat possible only for a team of artists, adding: 'We did it . . . at Cormon's, to amuse ourselves.' Puvis's classical calm is violated by a group of Montmartrois bohemians, including Lautrec and Willette, marshalled by a gendarme. Even the flying figures are made to carry tubes of paint, and a clock defaces the central architectural motif.

(*opposite*)
11 *In the Studio*
LILLE, Musée des Beaux-Arts. 1885. Oil on canvas 140 × 55 cm. Monogram bottom left.

One of Lautrec's rare painted copies, *In the Studio* was taken from Alfred Stevens's *The Painter's Studio* (Brussels, Musées Royaux des Beaux-Arts) of 1869. Stevens (1823–1906), a Belgian painter who settled in Paris, won great fame and wealth with his detailed and fashionable interior scenes. In this copy Lautrec removed the accessories typical of Stevens's work, notably a photograph of Baudelaire and a copy of Bruegel's *Numbering at Bethlehem*, suppressing finesse for the sake of extending the canvas and enjoying long lines in the paint (see Hervé Oursel, 'Un tableau de Toulouse-Lautrec', *La Revue du Louvre*, vol. 4, 1975).

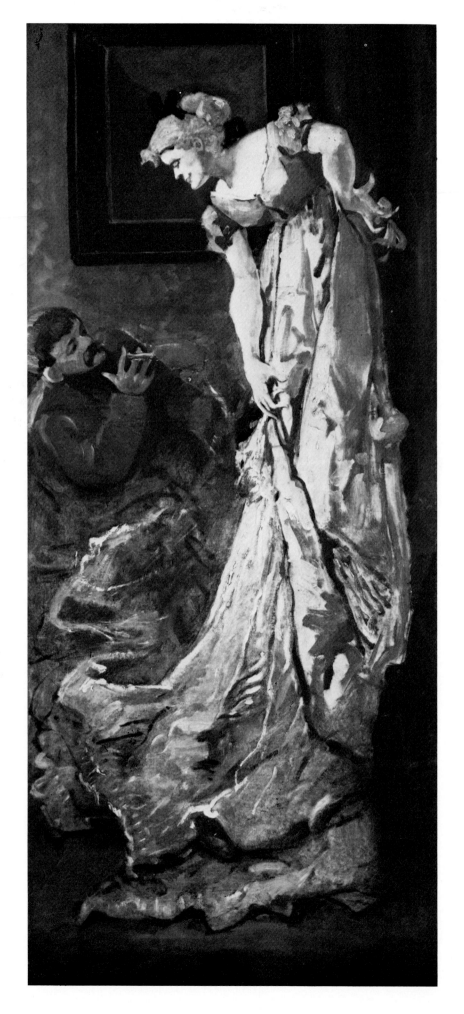

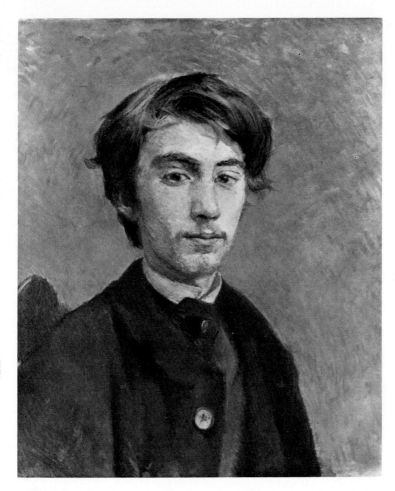

(*above left*)
12 *Emile Bernard*
LONDON, Tate Gallery. 1885. Oil on canvas 54·5 × 43·5 cm. Unsigned.

Bernard (1868–1941) joined Cormon's atelier in 1884 and soon befriended Lautrec and Anquetin. Corresponding with van Gogh, allied with Gauguin in establishing Synthetism, Bernard played an important rôle in the avant-garde of the 1880s. In his memoirs Bernard remembered that Lautrec needed some twenty sittings for this portrait in order to tally figure and background. The over-scrupulous reworking that the painter considered necessary is visible on Bernard's face, on which the brushstrokes were studiously handled to evoke texture and light.

(*above right*)
13 *The Quadrille of the Louis XIII Chair at 'The Elysée Montmartre'*
ALBI, Musée Toulouse-Lautrec. 1886. Charcoal, pen and ink 50 × 32 cm. Monogram bottom right.

These sketches, probably drawn at The Elysée Montmartre itself, are among the earliest portrayals of popular entertainment in Lautrec's *oeuvre*. This early in his career he showed himself interested in the characters and folkways of Montmartre. Rodolphe Salis, owner of Le Chat Noir cabaret, had left behind a Louis XIII chair when he left the establishment in 1885. Bruant took over the management of the cabaret, keeping the chair and writing a song about it which gave rise to the variation on the quadrille that Lautrec sketched here. This sheet contains portraits of Dufour, the conductor of the orchestra at the café-concert, and Père la Pudeur. Baptized Coutelat du Roche, Père la Pudeur was responsible for the morals of the Montmartre cabarets and music-halls, ensuring that the can-can dancers wore knickers underneath their many petticoats. Lautrec's drawing, sharply defining informally posed figures, indicates his debt to Forain (fig. 4) at this period.

(*opposite*)
14 *Vincent van Gogh*
AMSTERDAM, Rijksmuseum Vincent van Gogh. 1887. Pastel on cardboard 57 × 46·5 cm. Unsigned.

Van Gogh arrived in Paris from Antwerp in February 1886 and attended Cormon's atelier. Lautrec drew this portrait of Vincent, as the Dutchman then wished to be known, the year after they met, using for Lautrec the untypical medium of pastel. The painters seem to have been on reasonably good terms, although Suzanne Valadon recounted that Vincent was ignored by the people he met in Lautrec's studio. The latter certainly had a good opinion of Vincent's work, defending it against de Groux in 1890, and it may have been Lautrec who suggested that van Gogh should take up residence in the south of France in 1888. Lautrec came to favour the formula of a portrait seen in profile: the contour that outlines the head must take the burden of characterization. Here he concentrated on Vincent's features rather than his torso, setting off the proud profile against strong, right-angled lines and enlivening the whole surface with long, loose strokes.

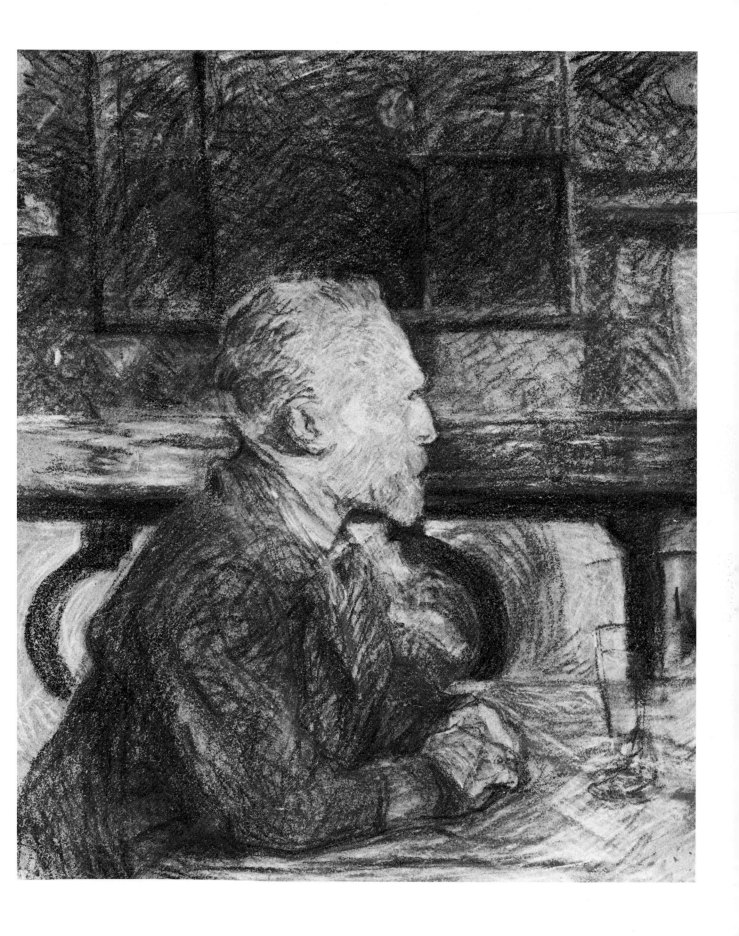

15 *Hélène V . . .*
BREMEN, Kunsthalle. 1888. Oil on cardboard 75 × 50 cm.
Signed bottom right.

The sitter for this portrait was probably one of Lautrec's
neighbours in Montmartre. Again, he utilized the profile
for a portrait, telling Gauzi that this girl's profile had a
'Greek' air. Lautrec had a photograph taken of Hélène,
presumably to aid his memory, and used it for this
painting and for a closer study also of 1888 (Albi, Musée
Toulouse-Lautrec). He painted her again in another
favourite pose, the model seen seated with the artist
working from almost behind her (France, collection of
P. Rosenberg, 1888). Lautrec showed *Hélène V . . .* at the
Cercle Volney in 1890. His exhibits there tended to be
tamer in subject and in style than those sent to the more
progressive Salon des Indépendants or Les XX; in 1891
Lautrec had his work hung at the Volney with that of
such conservative artists as Henner, Bouguereau and his
old teacher Bonnat.

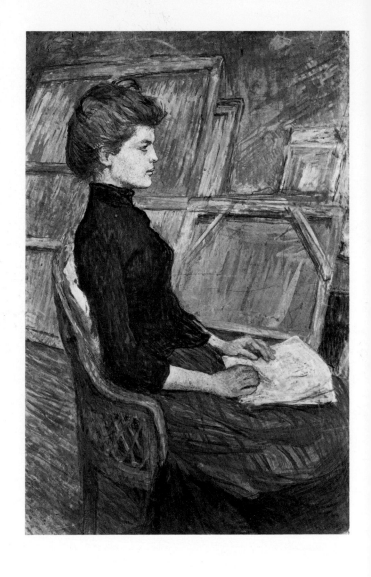

(*opposite*)
16 *Jeanne Wenz*
UPPERVILLE (Virginia), collection of Mr. and Mrs. Paul Mellon. 1888. Oil on canvas 72 × 49 cm.
Signed top right.

The sitter for this painting, also known as *A la Bastille,* was Jeanne Wenz. She was posed here as
Nini Peau-de-Chien, a seductress of the Bastille area, who is mentioned in one of Bruant's songs.
A drawing after this portrait was printed alongside the song itself in *Le Courrier Français* of 12 May
1889. Lautrec painted other female portraits as pendants to Bruant's lyrics, including *At Batignolles*
(London, private collection, 1888) and *At Grenelle* (New York, private collection, 1888). *Jeanne
Wenz* is notable as one of the firmly frontal poses with which Lautrec was experimenting as a
contrast to his frequent profile portraits, and the same model also sat for one of these (Chicago,
Art Institute of Chicago, 1886).

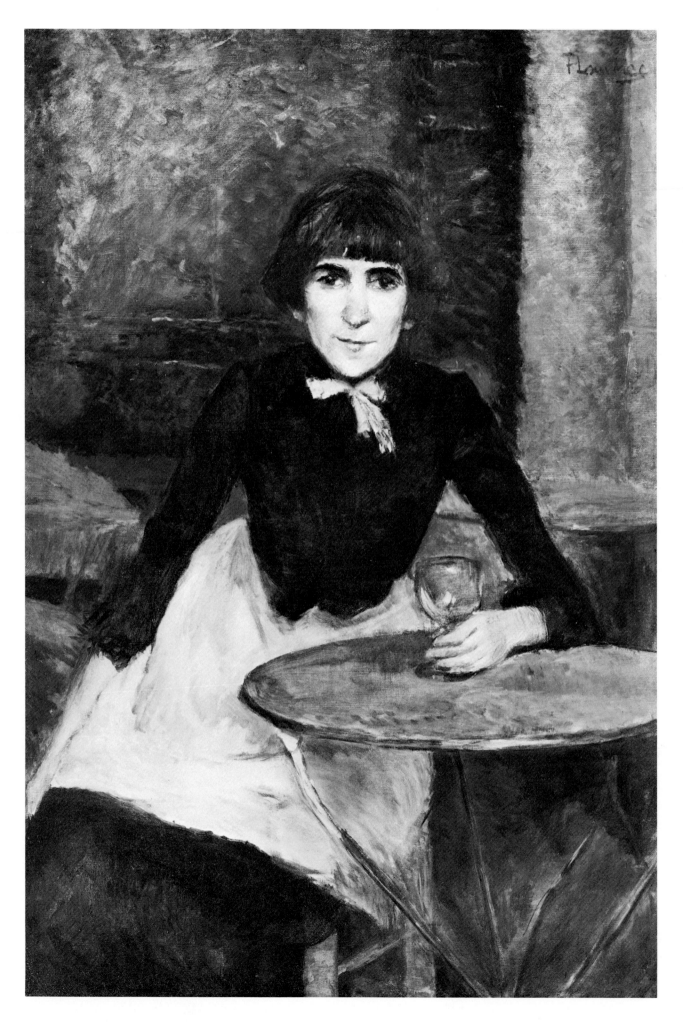

(*above left*)
17 *The Laundry-girl*
ALBI, Musée Toulouse-Lautrec. 1888. Charcoal on Ingres paper 65 × 50 cm. Monogram bottom left.

In *Paris illustré* of 7 July 1888, four of Lautrec's illustrations were added to Emile Michelet's text *L'Eté à Paris*. These four were *The Trace-horse of the Omnibus Company* (Paris, collection of Jacques Dubourg), *Riders in the Bois de Boulogne* (New York, collection of Dr. Marjorie Lewisohn), *First Communion* (Plate 18) and *The Laundry-girl*, for which this drawing was the first study. All four works are street scenes and all except *First Communion* include horses, Lautrec combining his new rôle as illustrator of city life with a motif he knew well. Again, all four have in common a deliberate adoption of devices drawn from Japanese art, pulling space up towards the picture plane, using the edges to sever shapes.

(*above right*)
18 *First Communion*
TOULOUSE, Musée des Augustins. 1888. Grisaille on cardboard 63 × 36 cm. Signed bottom left.

Another of the *Eté à Paris* series, this painting once belonged to François Gauzi who gave it to the Musée des Augustins in 1934. Gauzi posed for the male figure, and his recollections provide a valuable insight into Lautrec's working procedure. The painter apparently did not demand an absolutely still pose and chatted while he worked. Lautrec must have been consistent in this informality, for Paul Leclercq remembered a similar casualness when his own portrait was painted in 1897. Gauzi also recalled that the other figures were all painted from memory. It is significant that Lautrec began to develop the freedom of working from memory as his execution became less meticulous.

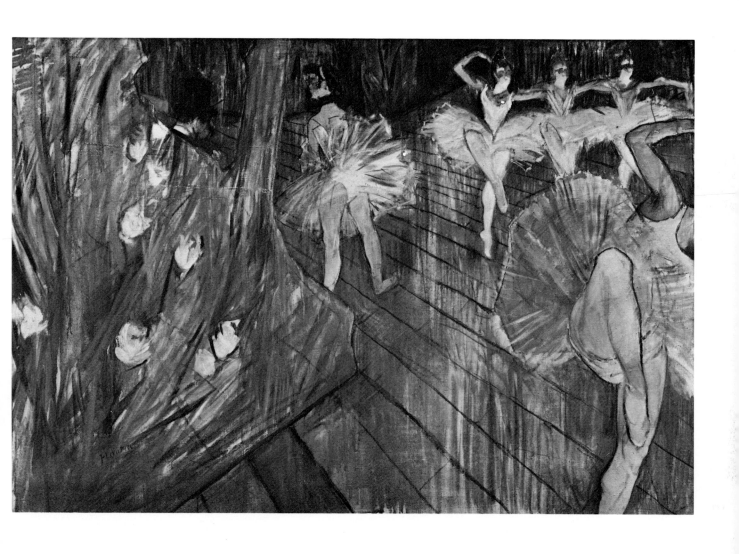

19 *Dancers*

STOCKHOLM, Thielska Galleriet. 1886? Oil on canvas 100 × 152 cm. Signed bottom left.

Dated 1886 by both Joyant and Dortu, the *Dancers* may have been painted slightly later. The considerably distorted perspective of the floor-boards, the quite confident description of the contours and the streaky, overlaid brushmarks suggest a date nearer 1888–90. Despite the asymmetrical *mis-en-place*, prompted by Japanese prints, the composition is not complicated, the diagonal running from the top-hatted onlooker to the group of three dancers forming a 'T' with the line running back from the front ballerina to the central girl with her turned back. The spatial openness, wrenched up towards the picture surface, and the deployment of large, thin shapes hint that, after a painting like this, Lautrec's transition to poster art was not a difficult one. In fact, there is a smaller picture of ballet dancers painted by Lautrec at much the same time as the Stockholm painting (private collection, 1886?) that utilizes a repetitive format similar to that of the later poster of *Mlle. Eglantine's Troupe* (Plate 68). Lautrec painted a number of pictures taking the ballet and its dancers as their theme in the second half of the 1880s, recognizing, as had Renoir, Forain and Zando-meneghi, the pictorial potentiality of the subject that Degas had pioneered.

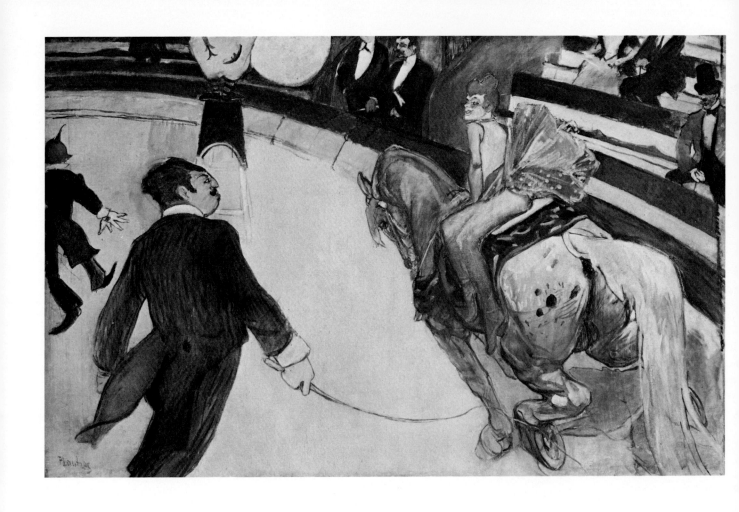

20 *At the Circus Fernando: the Equestrienne*

CHICAGO, Art Institute of Chicago (Joseph Winterbotham collection). 1888. Oil on canvas
98 × 161 cm. Signed bottom left.

Lautrec was professionally introduced to the spectacle of the circus, probably in 1882, by
Princeteau and John Lewis-Brown, another animal painter. This was the most ambitious of a series
of circus subjects undertaken sporadically by Lautrec between about 1888 and 1891, a theme
re-adopted with a cycle of drawings produced in 1899 (Plate 78). The setting is the Cirque
Fernando, later the Cirque Médrano, on the corner of the boulevard Rochechouart and the rue des
Martyrs, where Degas and Renoir had worked in the late 1870s. By the mid-'nineties Lautrec
himself was frequenting the smarter Nouveau Cirque. Choosing the circus as the subject for his
first large-scale picture and his first major public exhibition, Lautrec sent *The Equestrienne* to the
1888 show organized by Les XX in Brussels. Bought by Oller and Zidler, the owners of The Moulin
Rouge, the painting hung in the foyer of the music-hall, where it was admired by Seurat. *The
Equestrienne* is perhaps marred by an inconsistency of treatment. The solid figure of the ringmaster
M. Loyal contrasts abruptly with the flat clowns, and the monumental and curtly foreshortened
horse fits uncomfortably into space. The équestrienne herself was modelled by Suzanne Valadon,
who had sat for Delaunay, Puvis and Renoir and was Lautrec's mistress for a time. Later she had a
tumultuous affair with Erik Satie. Zandomeneghi had introduced her to Lautrec.

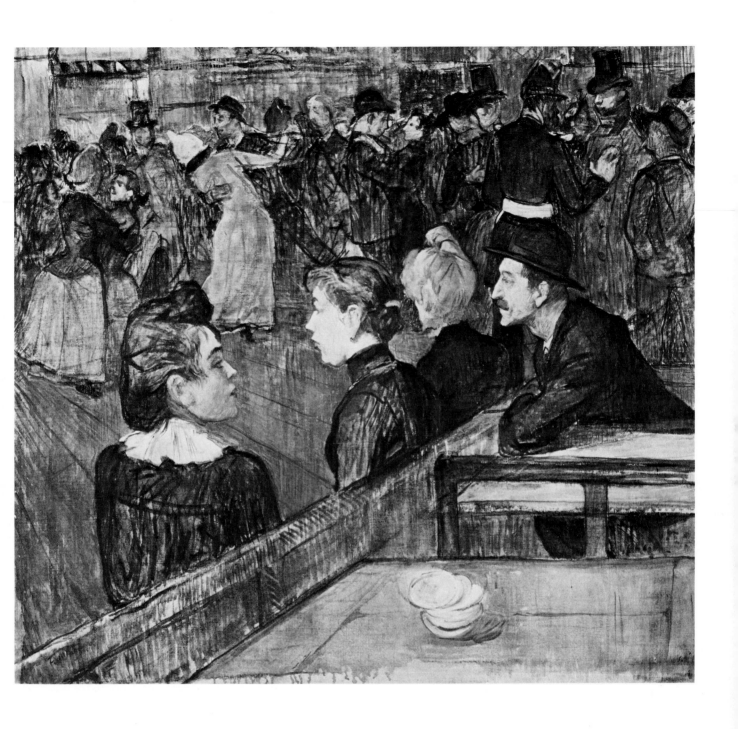

21　*The Ball at 'The Moulin de la Galette'*
CHICAGO, Art Institute of Chicago (Mr. and Mrs. Lewis L. Coburn memorial collection). 1889.
Oil on canvas 90 × 100 cm. Signed bottom left.

The Moulin de la Galette stood at the top of The Butte Montmartre, a very rough dance-hall
where Renoir had painted in the 1870s. Lautrec, who complained of the steep climb to reach it,
more or less gave up The Galette when The Moulin Rouge opened in 1889. He must have been
pleased with this painting, choosing it for his début at the 1889 Salon des Indépendants and show-
ing it with regularity during the next few years, at Les XX in 1890, with the Paris Arts Libéraux
in 1891, and at his 1893 one-man show at Boussod-Valadon's. The composition, perhaps a little
inflexible in its disposal of the forms, is based on the diagonal of the rail and the bowler-hatted
figure of the painter Joseph Albert, which together lock the bottom right-hand corner of the picture
into an 'L' shape. This is mirrored in the rear of the scene by the more amorphous arrangement of
the crowd. Lautrec's four foreground models are positioned as in an academic exercise, a gamut
of his favourite poses of the head, with two profiles, one *profil perdu,* and one head seen from almost
exactly behind. The colour range is that of the mature Lautrec. Submarine colours, washed-out
greens and translucent blues are dominant, with a few sharp accents of red but enlivened mainly
by diluted complementary contrasts of purple and yellow, red and green. The most abrupt value
contrasts are in the foreground areas and bring the figures towards the spectator.

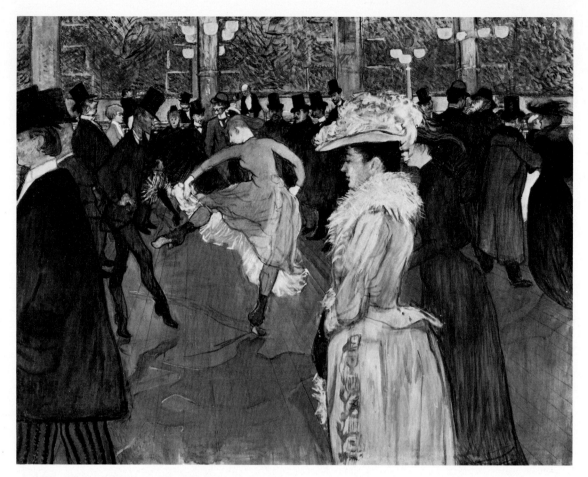

22 *The Dance at 'The Moulin Rouge'*
PHILADELPHIA, collection of Henry P. McIlhenny. 1890. Oil on canvas 115 × 150 cm. Signed and dated top right.

Between 1890 and 1896 Lautrec painted some thirty scenes at The Moulin Rouge. Opened in 1889 and an instant success, The Moulin Rouge was situated in the boulevard de Clichy. Decorated by Willette, who had named it, the music-hall had a substantial central dance-floor surrounded by a promenade and tables, various foyers and a garden. The managers, Oller and Zidler, organized a range of entertainments. Pictures, including some by Lautrec, were hung in the entrance. A number of notorious balls took place there, for example the second Bal des Quatz' Arts of 1893, a parody of Olympus. Above all, The Moulin Rouge was a centre of the *quadrille naturaliste*, a revival of the can-can. Many of the leading professional music-hall dancers performed there, including Grille d'Egout, Nini Patte-en-l'Air, La Môme Fromage, La Goulue and Valentin le Désossé, who is seen dancing with an unidentified girl in this painting. Lautrec included his friends in the crowd: at the centre stand Maurice Guibert, Paul Sescau and Gauzi. The white beard to the rear right probably identifies the artist Marcellin Desboutin (1823–1902), a friend of Degas and *habitué* of Montmartre who made a lithograph and a drypoint portrait of Bruant in 1895. But the central character of this scene is 'Boneless Valentin'. Valentin le Désossé (1843–1907) gained his nickname from his double-jointed dancing. His real name was Renaudin. Valentin worked for his notary brother by day and danced in the evenings. He gave his performances for no fee and was famous as the partner of La Goulue. *The Dance* was shown at the Salon des Indépendants in 1890.

(*opposite*)
III *Justine Dieuhl*
PARIS, Musée du Jeu de Paume. 1891. Oil on cardboard 75 × 58 cm. Signed bottom right.

Lautrec painted a number of portraits between 1888 and 1891 in the over-grown garden of Père Forest, on the corner of the boulevard de Clichy and the rue Caulaincourt. He called these paintings his 'impositions' and, as exercises, they established his personal brushwork and sharpened his eye for portraiture. Although the artist evidently enjoyed the clear, bright light he found out-doors, as in the keen but pleasing contrasts of red, blue and green in this painting, the series should not be viewed as an approach to an Impressionist sensitivity to light for the brushwork is too vigorous and the colour insufficiently varied. Lautrec preferred to generalize, to adopt a suitable schema, and many of these paintings treat the landscape elements as mere decorative accessories and rely on the juxtaposition of green and purple to give a clarity to the background. Lautrec made a witty play on the visual analogy between the leaves and the hat of the model, about whom nothing is known.

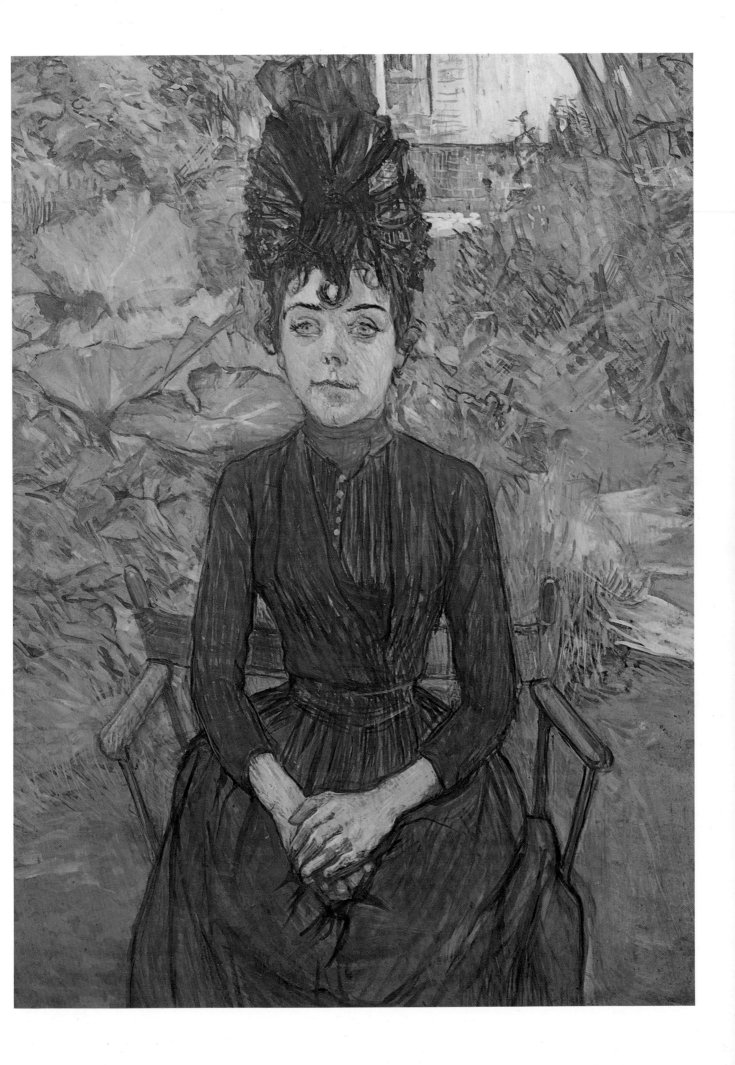

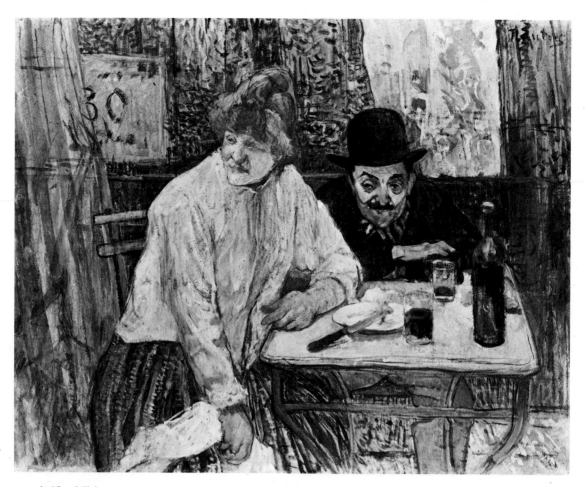

23 At 'La Mie'
BOSTON, Museum of Fine Arts (S. A. Denis fund). 1891. Oil on cardboard 53 × 68 cm. Signed top right.

This painting of Maurice Guibert and an unknown female model was posed at a café called La Mie and exhibited at the 1891 Salon des Indépendants. Guibert (1856–1913) was a salesman for Moët-et-Chandon champagne and a *roué* of redoubtable reputation. The journal *Fin de siècle* (7 July 1895) said of him that he was 'of the whole capital the man who knew the prostitutes best'. Guibert shared Lautrec's sensual disposition and activities and plays such a part in *At 'La Mie'*. As Douglas Cooper has pointed out, Lautrec never painted a serious portrait of Guibert, despite his regular appearances in the artist's *oeuvre*. Sescau took a photograph to assist Lautrec with this painting (see Mack, *Toulouse-Lautrec*, 1938, fig. 51). Lautrec's painter-friends Gauzi and René Grenier also took photographs for him, and Joyant noted that he used them 'often' for his work.

(opposite)
IV *Bruant aux 'Ambassadeurs'*
PARIS, Bibliothèque Nationale. 1892. Coloured poster 137 × 95 cm. (Adhémar 6).

Aristide Bruant (1851–1925) began his career as a café-concert singer. In 1885 he took over Rodolphe Salis's Chat Noir cabaret in the boulevard Rochechouart and changed its name to Le Mirliton. Here Bruant gave his famous performances, using his knowledge of the *langue verte*, the argot of the Paris slums, to spit out his songs about the life and conditions of the Montmartrois working people. By the turn of the decade Bruant had left the boulevard Rochechouart to perform at more respectable establishments. On 3 June 1892 he opened at Les Ambassadeurs, a café-concert that took its name from its proximity to the Hôtel Crillon, a favourite resort of foreign diplomats. The singer asked Lautrec to produce a poster to advertise the season, but Ducarre, the manager of Les Ambassadeurs, would only accept the design on condition that he paid for neither the original drawing nor the printing. In March 1892 Edmond de Goncourt had seen Bruant perform at the house of Charpentier, the publisher and friend of the Impressionists. De Goncourt noticed, as did Lautrec, Bruant's striking mien. 'He appeared dressed in a blood-red silk shirt, with a velvet jacket and long polished leather gaiters. Beneath a centre parting, fine, regular features, dark, velvety eyes in the shadows of deep brows, a short, straight nose, a dark, matt complexion, and in this face something half feminine, half cynical male, which produces the overall impression of an enigmatic androgyne.' De Goncourt was shocked that even society ladies liked Bruant's 'vocabulary of sordid brothels and clinics for venereal diseases'. Lautrec made three other posters of Bruant (Adhémar 7, 15, 71). As in several later posters (such as *May Belfort*, *May Milton* and *Jane Avril*; Plates 56, 57 and 67 respectively) a monumental figure is used to fill the picture space, the simplest of means for a bold effect.

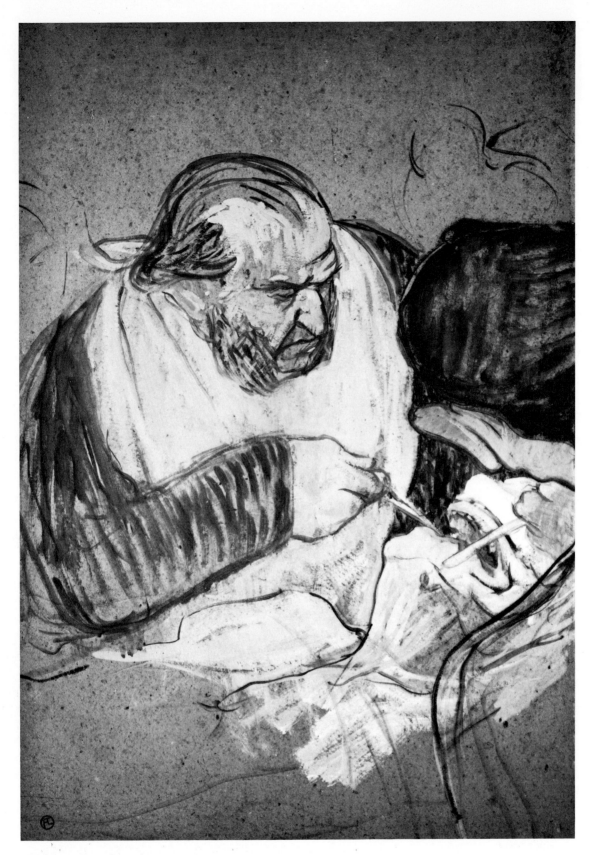

24 *Doctor Péan Operating*
WILLIAMSTOWN, Sterling and Francine Clark Art Institute. 1891. Oil on cardboard 74 × 50 cm.
Monogram bottom left.

Jules-Emile Péan (1830–98) was one of the most celebrated surgeons of the day and had been
painted by Gervex in 1887 (*Before the Operation*, Paris, Musée de l'Assistance Publique). Lautrec's
cousin Tapié de Céleyran, a medical student, took the painter to watch Péan's public and some-
what melodramatic operations. This oil sketch concentrates on Péan, though other figures have
been indicated behind him and the back of a head juts in front from the right edge. Lautrec
painted a second oil (France, private collection, 1891) which gives a larger view of the whole
operating theatre.

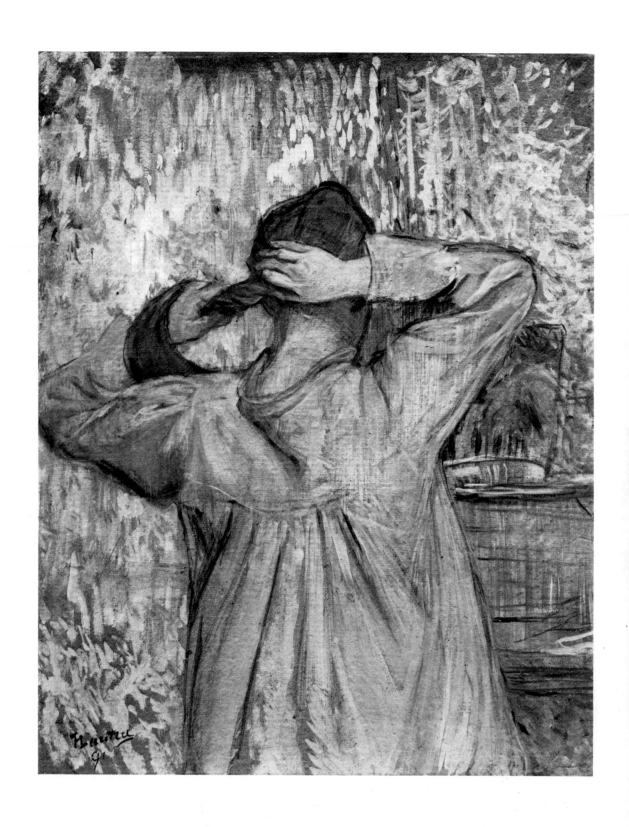

25 *Girl Combing her Hair*

OXFORD, Ashmolean Museum. 1891. Oil on cardboard 58 × 46 cm. Signed and dated bottom left.

Lautrec made several similar studies in 1891, for example the *Woman Curling her Hair* (Toulouse, Musée des Augustins). The Ashmolean painting was not exhibited until the Salon d'Automne retrospective of 1904, but two versions of a seated girl arranging her hair were shown at the Salon des Indépendants in 1892 (Paris, Musée du Jeu de Paume, 1891 and Winterthur, Reinhart Collection, 1891). Lautrec would no doubt have been aware that Degas had exhibited a series of *scènes de toilette* at the last Impressionist group show in 1886.

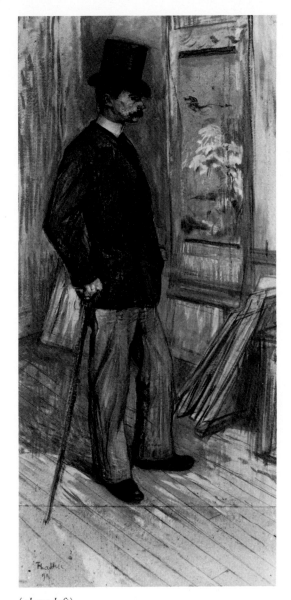
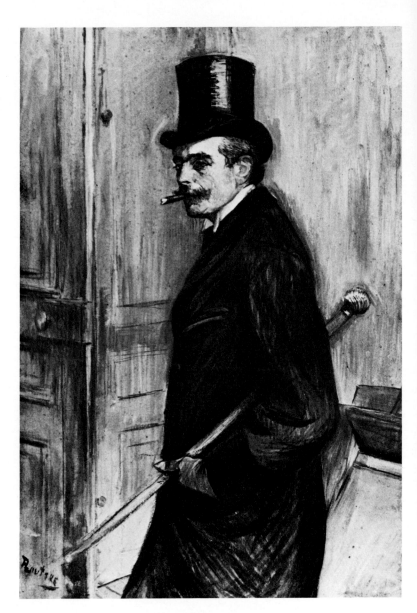

(*above left*)
26 *Paul Sescau, Photographer*
NEW YORK, Brooklyn Museum. 1891. Oil on cardboard 82·5 × 35·6 cm. Signed and dated bottom left.

Sescau had his studio at 9 Place Pigalle and used the opportunities provided by his professional tasks to further his reputation as a *coureur des femmes*. Lautrec commented on this in the poster he made to advertise his friend's business in 1894 (Adhémar 69). Sescau also appears in one of the panels Lautrec painted for La Goulue (Plate 32) and in the lithograph *Promenoir* (c. 1899, Adhémar 324), among other works. In 1895 Sescau sold this portrait to the critic Roger Marx, an admirer of Lautrec, for 400 francs. The artist acted as intermediary and wrote to the buyer, 'I consider it one of my best.' A strip of cardboard was added at some stage to the bottom edge of the painting, Lautrec thus successfully shifting the figure back into space. This formula for male portraiture, with the model caught full-length in an informal pose, was derived from Degas (fig. 10). Lautrec used it on several occasions in the early 1890s and again at the end of the decade, as in *Louis Bouglé* (Paris, private collection, 1898).

(*above right*)
27 *Louis Pascal*
ALBI, Musée Toulouse-Lautrec. 1891? Oil on cardboard 77 × 53 cm. Signed bottom left.

A cousin of Lautrec, Louis Pascal had been at school with him at the Lycée Fontanes, later the Lycée Condorcet. He was an amiable *bon viveur* and insurance broker, whose father was Prefect of the Gironde. In a letter of February 1891, Lautrec mentioned working on this portrait, which may have been shown at the Salon des Indépendants in March of that year. Coquiot described it in this context, along with the portrait of Bourges (which is dated 1891). However, neither picture is included in the Salon catalogue and Joyant, followed by Dortu, dates the Pascal portrait to 1893. *Louis Pascal* is a variant on the formula that Lautrec had used for several male portraits (Plate 26). As a half-length of an elegant gentleman with a top-hat and cane, it might possibly owe something to a recollection of Manet's *Antonin Proust* (Toledo (Ohio), Toledo Museum of Art, 1880), which Lautrec could have seen at the posthumous retrospective of Manet's work in 1884.

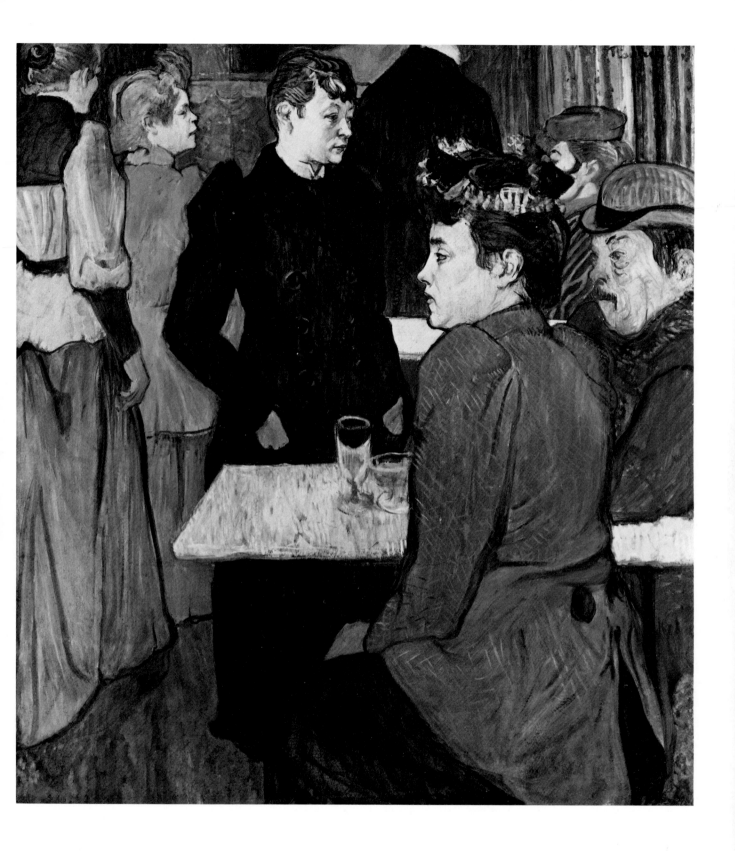

28 *A Corner of 'The Moulin de la Galette'*
WASHINGTON, National Gallery of Art (Chester Dale collection). 1892. Oil on cardboard
100 × 89 cm. Signed top right.

With this painting Lautrec chose to focus his attention on a section of the crowd rather than
following his more usual practice of distancing the figures from the onlooker, pushing them back
into the picture space. Here the spectator is pulled right into the picture by the diagonals estab-
lished by the extreme right and left pairs of figures, which reach out either side of him, and by his
very proximity. In 1893 the *Corner of 'The Moulin de la Galette'* was shown in February at Lautrec's
exhibition, shared with Charles Maurin, at Boussod-Valadon's and again in April at the Salon des
Indépendants.

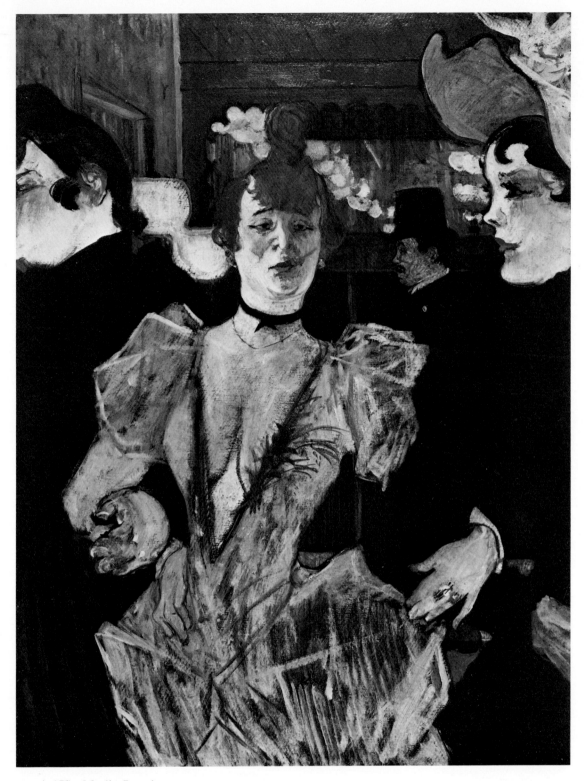

29 *At 'The Moulin Rouge'*
NEW YORK, Museum of Modern Art (gift of Mrs. David M. Levy). 1892. Oil on cardboard
46·8 × 35·4 cm. Signed bottom left.

The central figure is La Goulue ('the glutton'), one of the leading stars of The Moulin Rouge. As
Louise Weber (1870–1929) she began life as a laundry-girl in Alsace. In Paris she started in the
same stock situation as Zola's young Nana, as a flower-seller, losing her virginity at the age of
thirteen to an artilleryman in the suburb of Saint-Ouen. La Goulue worked at The Moulin de la
Galette and The Jardin de Paris before settling in the autumn of 1890 at The Moulin Rouge,
where she remained until obesity ended her stardom. In the Museum of Modern Art's painting
La Goulue is seen walking through the music-hall, accompanied by her sister and, on the right,
perhaps Nini Patte-en-l'Air. Lautrec's acute powers of observation did not miss the contrast of
diaphanous dress and sagging breasts. His increasing facility with this combination of media,
especially his ability to allow the cardboard to play a rôle, is apparent in this work, for the dark
patches on La Goulue's torso come from the bare board below. *At 'The Moulin Rouge'* was shown at
the Boussod-Valadon exhibition of 1893.

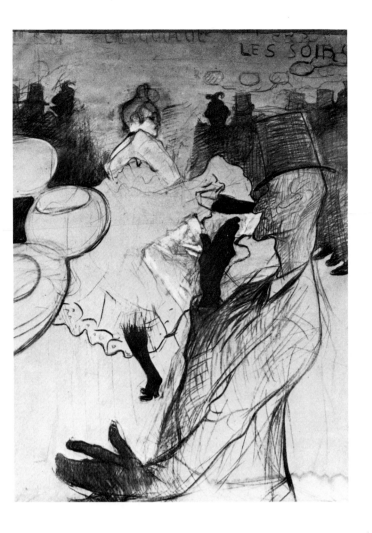 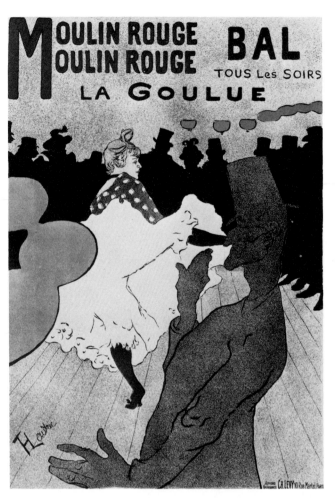

(*above left*)
30 *La Goulue at 'The Moulin Rouge'*
ALBI, Musée Toulouse-Lautrec. 1891. Charcoal, heightened with colour, on canvas 154 × 118 cm. Unsigned.

(*above right*)
31 *La Goulue at 'The Moulin Rouge'*
PARIS, Bibliothèque Nationale. 1891. Coloured poster 195 × 122 cm. (Adhémar 1).

Zidler commissioned this poster from Lautrec, to follow the one Chéret had designed for the opening of The Moulin Rouge. Lautrec was obviously pleased with the result. He wrote to his mother that 'it has been fun to do. I had a feeling of authority over the whole studio, a new feeling for me.' In the event, this design launched Lautrec's career as a successful poster artist. He sent it to the Exposition Internationale de l'Affiche at Rheims in November 1896, when his reputation was fully established, but as early as 1892 Chéret himself said in an interview that Lautrec was a 'master'. There were many descriptions of La Goulue's act in the popular press. *Gil Blas*, in May 1891, reported how 'she allows the spread of her legs to be glimpsed through the froth of pleats and reveals clearly, just above the garter, a small patch of real, bare skin.' Other accounts tell of a far more lascivious display. The strokes of the canvas, the final study for the poster, show how Lautrec contrived to pivot the axis of the design on La Goulue's sex. This effect is played down in the poster itself, in which the flatter treatment of crowd, petticoat and partner subdues the more frenzied drawing of the study. But still the poster revolves around the central, propeller-like pose of La Goulue, echoed in the foreground by the eccentric gas-lights and acting in the space established between Valentin le Désossé and the background crowd.

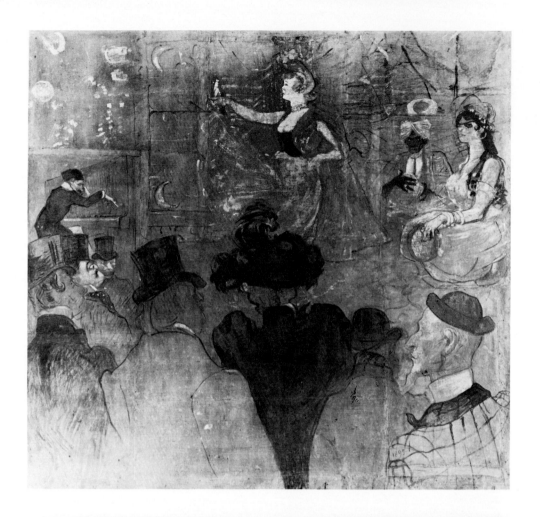

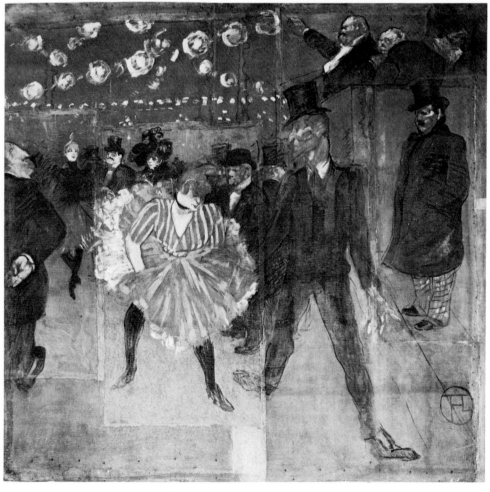

34 *Flirt*

ALBI, Musée Toulouse-Lautrec. 1892. Coloured lithograph 47 × 37·2 cm. (Adhémar 3).

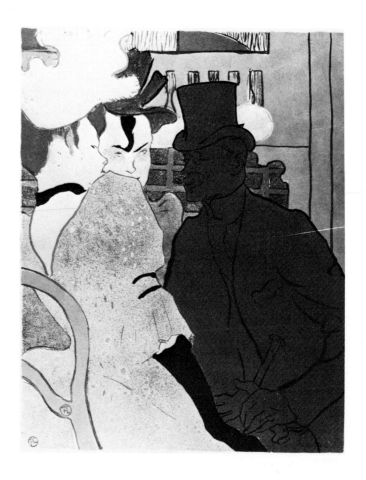

One of Lautrec's very first lithographs, this print is also known as *Rencontre au 'Moulin Rouge'* and *L'Anglais Warner au 'Moulin Rouge'*, the latter title preferred by Adhémar. *Flirt* was Lautrec's own choice. The male figure was indeed an Englishman, but his name was Warrener. Son of a Lincoln coal-merchant, W. T. Warrener (1861–1934) arrived in Paris during the mid-1880s to study at the Académie Julian. Warrener was a painter, while Warner was apparently a music-hall impresario. There is conclusive evidence to prove that Warrener was the model. Warrener was a friend of William Rothenstein, who, in turn, knew Lautrec. The oil study for this lithograph (New York, Metropolitan Museum of Art, 1892) was once owned by Warrener (see the exhibition catalogue *W. T. Warrener*, July–September 1974, Usher Gallery, Lincoln). The composition is an excellent example of Lautrec's assimilation of the formal lessons of Japanese prints. Simplified line is used over flat colour areas to give the minimum sense of descriptive solidity, a direct adaption of Japanese devices. This is especially apparent in the figure of Warrener. The cultivated informality of the superimposition of sitter over sitter is far from casual. Complex linear concentrations, Warrener's face, for instance, are surrounded by more visually obvious passages, here, the grid. And the chair-back is echoed in depth by the front girl's hunched shoulder and by Warrener's own left shoulder. This degree of sophistication shows how articulate Lautrec had become in the vocabulary of Japanese art by 1892.

(opposite top)
32 *La Goulue Dancing (La Danse de l'Almée)*
PARIS, Musée du Jeu de Paume. 1895. Oil on canvas 285 × 307·5 cm. Monogram and date bottom right.

(opposite bottom)
33 *La Goulue Dancing with Valentin le Désossé*
PARIS, Musée du Jeu de Paume. 1895. Oil on canvas 298 × 316 cm. Monogram bottom right.

By 1894 observers remarked that the quadrille was in decline. La Goulue's career began to fade simultaneously and, considerably overweight, she left The Moulin Rouge. In 1895 she performed in her own pavilion at the annual Foire du Thrône at Neuilly, asking Lautrec to paint decorative panels for the booth. He hastily improvised these enormous canvases, peopling them with figures from La Goulue's hey-day. In one she is seen dancing with her former partner Valentin le Désossé, watched from the left background by Guibert, as Dufour of The Elysée-Montmartre café-concert conducts. The other panel shows La Goulue performing a belly-dance, itself imported to France as part of a whole Cairo street-scene for the Exposition Universelle of 1889. The piano is played by M. Tinchant of Le Chat Noir, and the spectators are Sescau, Guibert, Tapié, M. Sainte-Aldegonde, Jane Avril, Lautrec and, finally, the eccentrically bearded Fénéon. La Goulue's career continued to wane. In 1896 she resorted to wrestling, and in 1900 she could be seen performing with lions and a panther. Her last years were spent working as a domestic servant in a brothel.

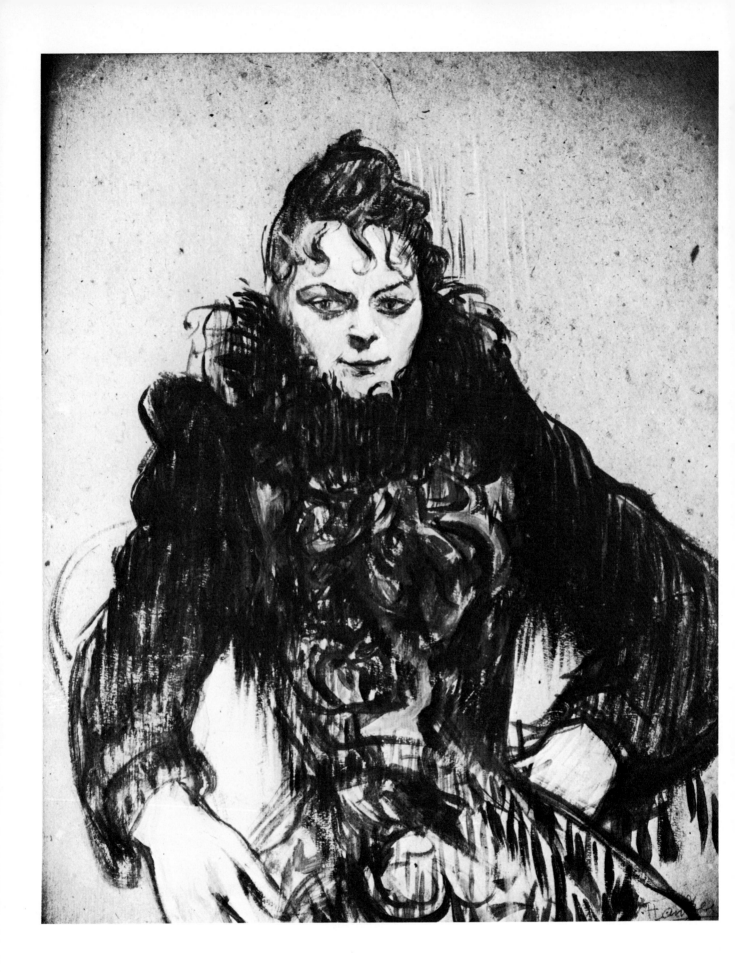

36 Caricature Self-portrait

ROTTERDAM, Boymans-van Beuningen Museum. c. 1892.
Black chalk 25·5 × 16 cm. Monogram bottom left.

Throughout his career Lautrec sketched swift caricatures,
not for publication but for his own amusement and that of
his friends. There are sketches of Catulle Mendès, Rodin,
Fénéon and Degas, among others. Lautrec did not spare
himself, as this simian rendering shows.

(opposite)
35 Woman with a Black Boa

PARIS, Musée du Jeu de Paume. 1892. Oil on cardboard 52 × 41 cm. Signed bottom right.

This painting is a fine instance of Lautrec's abilities as a portraitist and also of his instinct for
sensing when the effect he wanted was realized. He concentrated here on the physiognomy, expertly
conjuring up the sitter's gaze, alluring yet lethal. Confounding the title, the paint surface is in fact
a play of a variety of blues and greens rather than black. Exhibited in London in 1898, the picture
was given to the Luxembourg Museum, then the French national collection of contemporary art, by
the comtesse de Toulouse-Lautrec in 1902.

(overleaf)
37 Jane Avril Dancing

PARIS, Musée du Jeu de Paume. 1892. Oil on cardboard 84 × 44 cm. Signed top right.

Jane Avril (1868–1923) appeared frequently in Lautrec's paintings and lithographs. Theirs was a
closer and longer lasting relationship than Lautrec had with most of his models. The daughter of
a courtesan and an Italian nobleman, Jane Avril had a childhood interrupted by mental disorder.
She became a dancer and performed under the name 'La Mélinite', a new type of explosive.
Beginning at The Moulin Rouge she moved on to The Décadents, Le Divan Japonais and The
Jardin de Paris. At this last café-concert she was seen by Arthur Symons, an English poet and
acquaintance of Lautrec, who left the following account of her act. 'She danced in a quadrille:
young and girlish, the more provocative because she played as a prude, with an assumed modesty;
décolletée nearly to the waist, in the Oriental fashion. She had long black curls around her face; and
had about her a depraved virginity.' Jane Avril preferred to work as a solo dancer, as Lautrec has
portrayed her in this picture. Warrener can be seen in the background, wearing a bowler. This is
one of the works exhibited at Lautrec's one-man show at the Goupil Gallery, London in 1898.

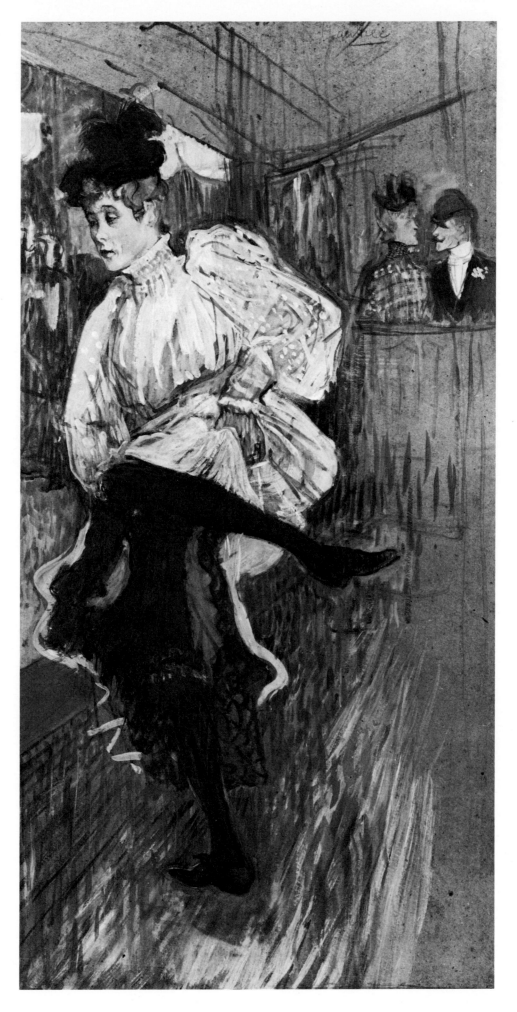

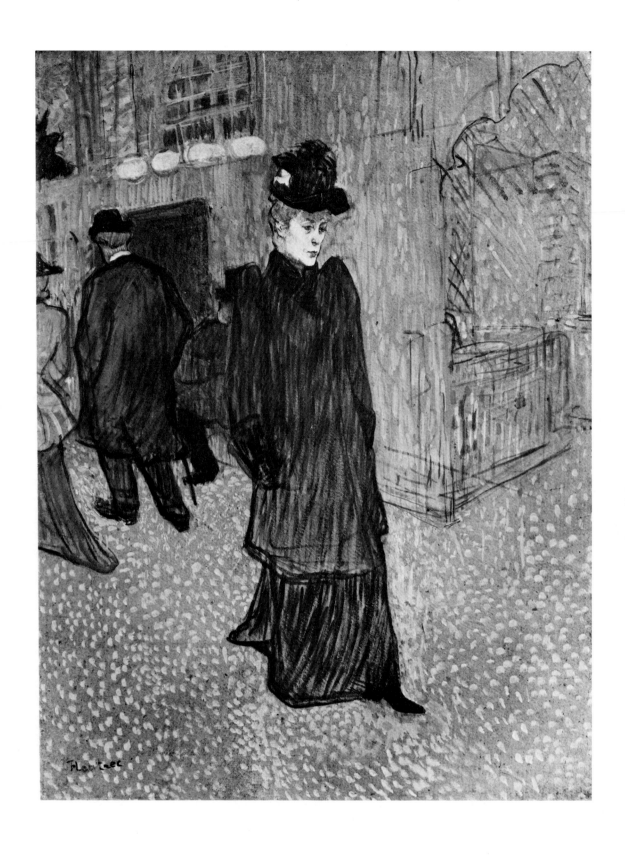

38 *Jane Avril Leaving 'The Moulin Rouge'*
HARTFORD, Wadsworth Atheneum. 1892. Oil on cardboard 84·3 × 63·4 cm. Signed bottom left.

Although rather a slight work, this painting shows Lautrec attempting to enliven the cardboard surface with a loose *pointillé* touch in yellow, as a contrast to the long strokes in complementary purple of Jane Avril's clothing. The man in the distance is Charles Conder (1869–1909), a painter of Australian origin who worked in Paris in the early 1890s. Rothenstein recounts that Lautrec, with characteristic generosity, introduced Conder's canvases and the artist himself to Père Thomas, a picture dealer on the boulevard Malesherbes. Conder once almost fought a duel with Dujardin, another friend of Lautrec (Plate 66), over a certain Germaine. Like *Jane Avril Dancing* (Plate 37), this painting was shown in London at the 1898 exhibition.

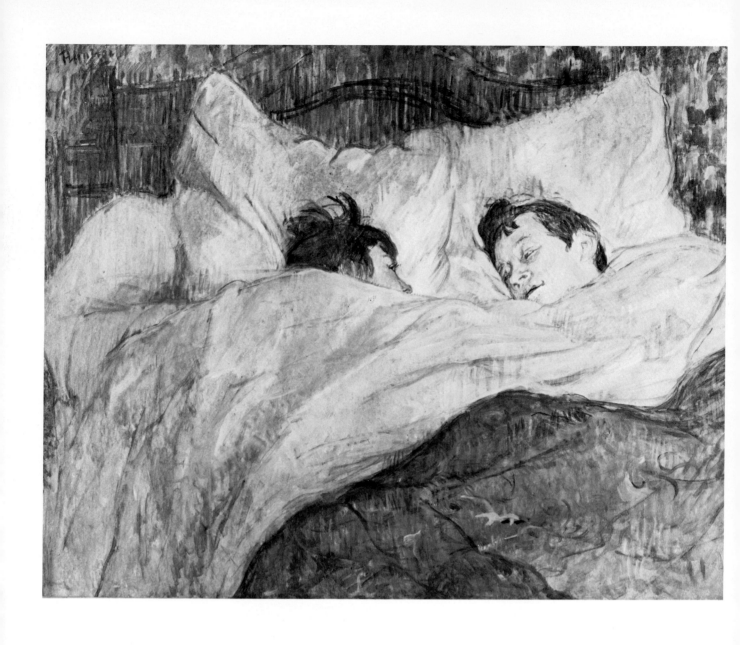

39 *In Bed*
PARIS, Musée du Jeu de Paume. 1892. Oil on cardboard 64 × 59 cm. Signed top left.

Lautrec seems to have begun painting lesbian couples in 1892, and *In Bed* is one of the first. There are four pictures of this pair of women, one of which (*The Kiss,* Paris, private collection) was exhibited in December 1892 at Le Barc de Boutteville's gallery. The carefully arranged brush-strokes placed, in some areas, flush to the picture surface in vertical dabs suggest that Lautrec was responding in both *The Kiss* and *In Bed* to the contemporary work of Vuillard and Bonnard, who were also shown by Le Barc. The artist registered his awareness of lesbianism as a thematic possibility as soon as he began to work in the brothels but, after this group, he appears not to have acted upon this again until 1894. Lautrec's interest in this kind of love was sympathetic, unlike, for instance, Courbet's frankly titillating treatment. Lesbians featured with some frequency in *fin-de-siècle* art, in the work of Rops, Klimt and especially the Belgian sculptor Victor Rousseau. This painting was once owned by Roger Marx.

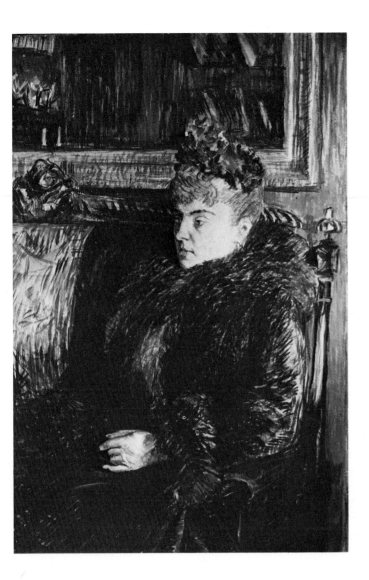

(*above left*)
40 *Madame de Gortzikoff*
LONDON, private collection. 1893. Oil on cardboard 76 × 51 cm. Unsigned.

The sitter has always eluded identification, although this was Lautrec's only commissioned portrait. Perhaps the pressures of the commission tacitly encouraged the painter to take such care over the face, in contrast to the loose, jagged brushwork visible in the background, on the sofa and mirror.

(*above right*)
41 *Loïe Fuller*
PARIS, Bibliothèque Nationale. 1893. Lithograph 43 × 27 cm. (Adhémar 8).

Loïe Fuller (1862–1928) was an American dancer who made her Paris début at the Folies-Bergère in November 1892. She was widely acclaimed in the Paris season of 1893–94 and several other artists were attracted to her performance; Whistler made sketches and Pierre Roche a well-known sculpture. Loïe Fuller named her dances in accordance with the imagery of Art Nouveau, taking such titles as the Lily Dance, the Fire Dance, the Butterfly Dance. Her long, flowing gown was manipulated by long sticks held in each hand, as the dancer herself stood still. The swirling material was illuminated from below by coloured lights projected through a square of glass set in the stage floor, and the mood of the title aroused by appropriate colours and movements. Lautrec had hoped that she would commission a poster, but Chéret was asked instead. Reacting with typical rapidity to a new talent, Lautrec responded to this set-back by printing fifty copies of this black-and-white lithograph in February or early March 1893. They were hand-coloured by the artist himself, and dusted with gold powder. Lautrec thus gave an individual identity to each copy and, with one basic image, emulated the different colour effects of the dancer's performance.

67

V *At 'The Moulin Rouge'*
CHICAGO, Art Institute of Chicago (Helen Birch Bartlett memorial collection). 1892. Oil on canvas 123·5 × 141 cm. Monogram bottom left.

With this painting Lautrec produced what almost amounts to a retrospective view of his strictly Montmartrois period. Depicting the music-hall with which he was most associated, typically, he included a number of his friends. Seated around the table are the bearded Dujardin, a dancer called La Macarona, Sescau, Guibert and an unknown woman with her back to the spectator. The figure at the front right was identified by Joyant as Miss Nelly C., with the blunt colour complementaries of her mask-like face not one of Lautrec's best likenesses although it gives a striking physical presence on the first plane. In the background are Tapié de Céleyran, the artist himself, and La Goulue arranging her hair in the mirror. The composition emphasizes the diagonal, like the earlier *Ball at 'The Moulin de la Galette'* (Plate 21), but with greater expertise in the placement of figures in a design. Lautrec added canvas to the painting both along the bottom and the right edges. This enabled him to include Nelly C. and to extend the balustrade that pushes back into space in the left foreground. The diagonal formed by the balustrade is echoed by another, which runs from Lautrec, through Sescau and Guibert, towards Nelly C. These two lines, one stated, the other implied, enclose the circle of carefully drawn portraits around the central table. It has been suggested that the asymmetrical composition of *At 'The Moulin Rouge'*, although obviously informed by Japanese prints, was directly borrowed from Gauguin's *Night Café* (fig. 7). However, there is no evidence that Lautrec knew the Gauguin painting and by 1892 he was not in the habit of appropriating whole compositional schemes.

VI *The Salon at the rue des Moulins*
ALBI, Musée Toulouse-Lautrec. 1894. Oil on canvas 111·5 × 132·5 cm. Monogram bottom left.

The many preliminary drawings produced for this work suggest that from the outset Lautrec considered *The Salon at the rue des Moulins* to be the monumental summation of his work in the brothels. There is a calm and stability in this painting not to be found in earlier large works, such as the Chicago *At 'The Moulin Rouge'* (Plate V). Lautrec used a number of means to achieve this. The middle column firmly establishes the centre of the picture space and the eye is led into depth by the two sets of overlapping figures to the left and right of it. The nearest *fille* fixes space in front of the column. Despite the greater detail in the accessories than Lautrec usually brought into his brothel paintings, the picture is handled in substantial, blank colour areas rather than his usual and more vibrant linear overlay of brushstrokes. The prostitutes waiting for their clients are arranged in the profile and frontal poses that Lautrec favoured in his portraiture, while the colour range is based on a gentle contrast of complementary green and red. Although the painter worked hard on this picture—in the Albi Museum there is even a full-scale pastel study—he did not choose to show it in his lifetime. *The Salon at the rue des Moulins* was first exhibited to the public in 1914.

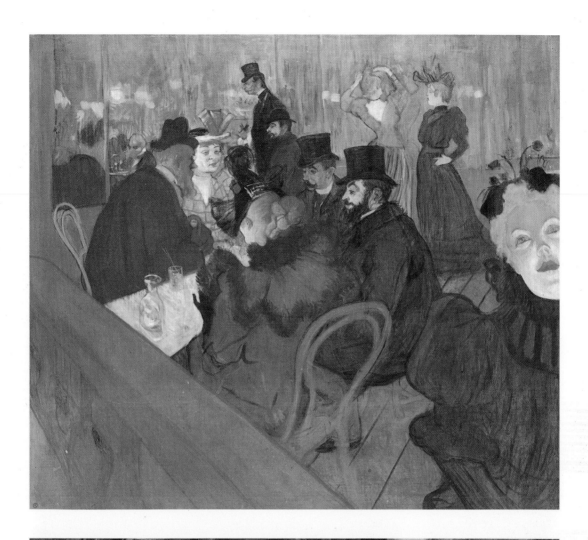

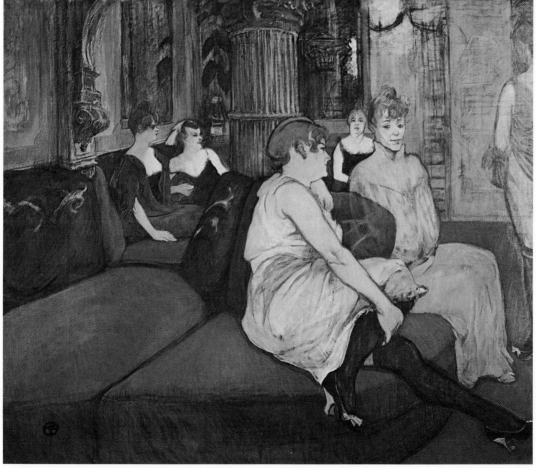

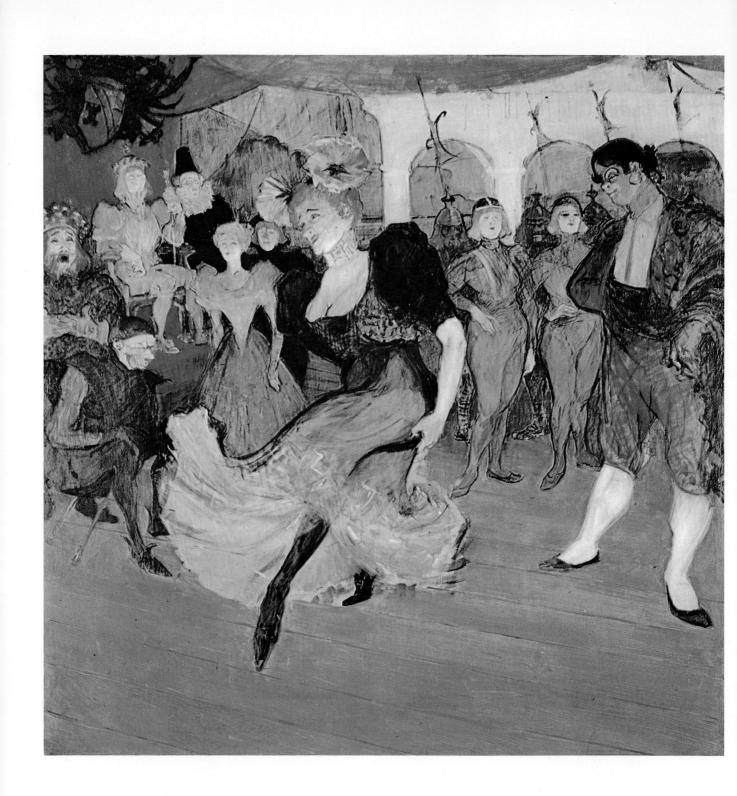

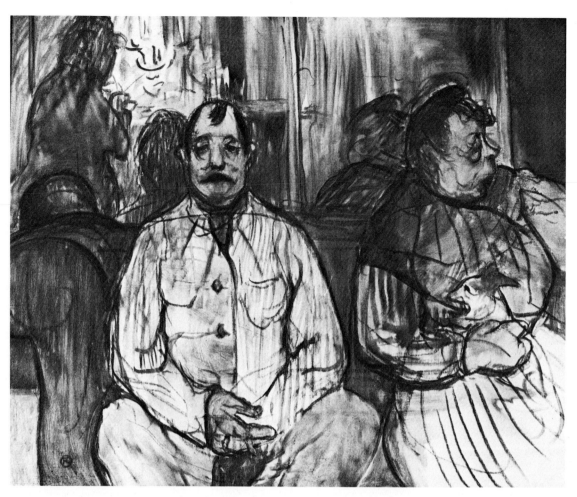

42 *Monsieur, Madame and the Dog*
ALBI, Musée Toulouse-Lautrec. 1893. Oil on canvas 48 × 60 cm. Monogram bottom left.

Joyant referred to this couple as the proprietors of a brothel. They are seated against a mirror, in which are reflected hints of activity behind the spectator. The paint has been thinned and applied like a wash over simple underdrawing, a handling that looks forward to the broad colour areas of *The Salon at the rue des Moulins* (Plate VI). Although the imagery of the prostitute and the brothel had been used before Lautrec, it is by no means clear what made him decide to concentrate so much of his creative enthusiasm on it. Perhaps the publication of Edmond de Goncourt's *Outamaro, le peintre des maisons vertes* in 1891 helped persuade Lautrec that the whore was a legitimate and fruitful subject for the draughtsman. 'Green houses' was the euphemism given by the Japanese to their brothels.

(opposite)
VII *Marcelle Lender Dancing the Bolero in 'Chilpéric'*
NEW YORK, private collection. 1896. Oil on canvas 145 × 150 cm.
Monogram bottom left.

Chilpéric, an operetta by Hervé in the genre of *La belle Hélène*, opened at the Théâtre des Variétés in February 1895 to great acclaim. The scene Lautrec chose to portray shows the actor Brasseur as the eighth-century Frankish king Chilpéric watching his Spanish bride Galswintha, played by Marcelle Lender, dance a bolero. The figures in the background, from left to right, are the actors Lassouche, Vauthier, Brasseur, Baron and Amélie Diéterle with Simon standing on the right. Lautrec went to see some twenty performances of *Chilpéric* and produced many sketches, several lithographs and, above all, this painting, the most important of his theatre pictures. He was obsessed with Lender's back, and one of the lithographs depicts it (1895, Adhémar 127). Perhaps it is strange that this particular and widely reported fascination should have appeared only once as a motif, and even then her back is treated in accordance with Lautrec's earlier formula for portraying women from behind, found in *The Ball at 'The Moulin de la Galette'* (Plate 21) and *At 'The Moulin Rouge'* (Plate V) and several other works. When Lender came to pose in Lautrec's studio he made her sing the same couplet from *Chilpéric* over and over again during the sitting. He did not want her to sing another because it might distract him, but he wanted her to sing 'because, when you are singing, your skin scintillates imperceptibly in the light, and that's what I'm looking for'.

71

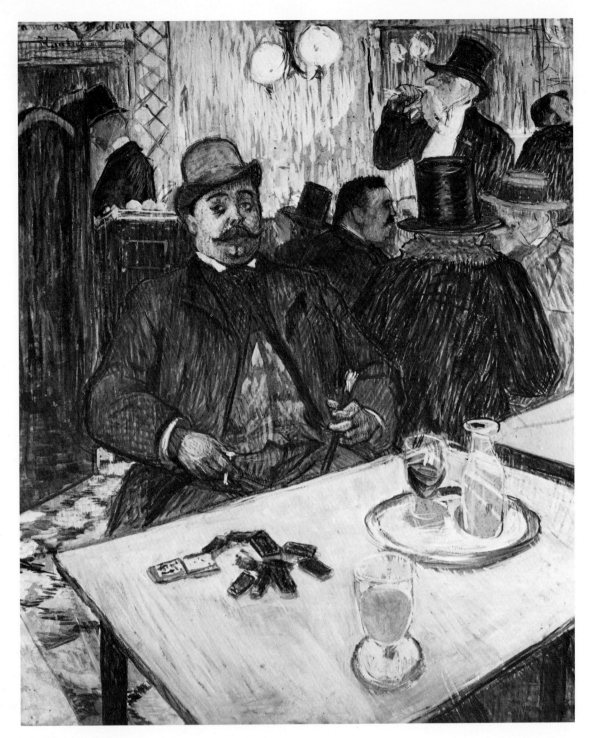

43 *Monsieur Boileau*
CLEVELAND, Cleveland Museum of Art (Hinman B. Hurlbut collection). 1893. Oil on canvas
80 × 65 cm. Signed and dedicated top left: à mon ami Boileau.

Very little is known about M. Boileau, except that he was a familiar figure in the cafés and bars
of Montmartre. According to Mack, he worked as a journalist, specializing in scandal. Lautrec's
father, with white beard and top-hat, can be identified in the background. This portrait was
exhibited at the Salon des Indépendants in 1893.

(*opposite*)
44 *Alfred la Guigne*
WASHINGTON, National Gallery of Art (Chester Dale collection). 1894. Oil on cardboard 65 × 50 cm.
Signed and dedicated bottom right: Pour Méténier d'après son Alfred la Guigne.

Alfred la Guigne was a character from a contemporary novel of the same name by Oscar Méténier,
to whom the picture is inscribed. Méténier, a friend of Bruant, published the singer's biography in
1893. Posed by Gaston Bonnefoy, Lautrec's painting is at once a rare departure into literary subject

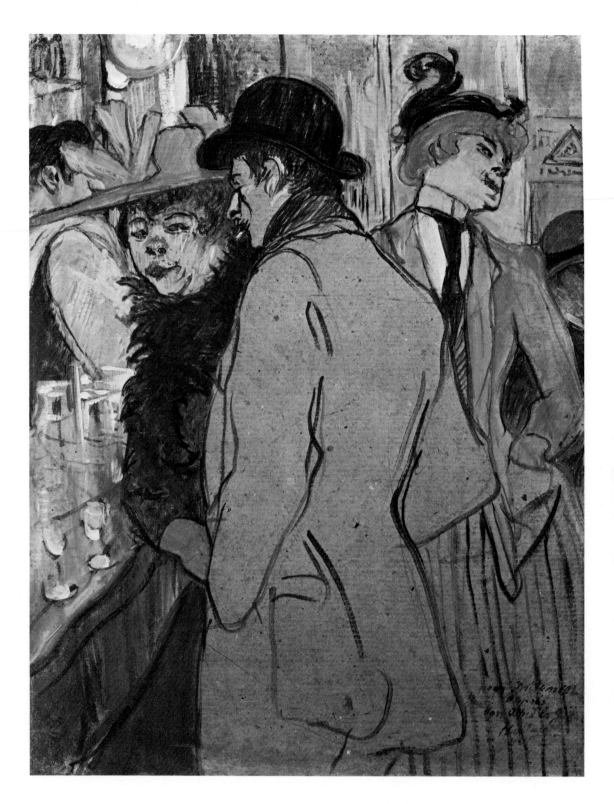

matter and a remarkable feat of characterization of this *coureur des femmes*. The picture weakens a little towards the bottom corners but, nevertheless, Lautrec's dynamic use of line prevents the blank cardboard of Alfred's body from inactivity in the design. Lautrec had probably adopted the technique of painting on cardboard from Raffaëlli (1850–1924), who was admired by Degas and van Gogh for his paintings of the urban poor and their world. In April 1884 Raffaëlli exhibited some works on cardboard at a little shop on the avenue de l'Opéra, Joyant noting later that this might have attracted Lautrec. Lautrec was certainly impressed by Raffaëlli's exhibition in 1890, organized at Goupil's by Théo van Gogh. When Lautrec's work was exhibited in the same gallery three years later, Raffaëlli noticed that Lautrec had followed his lead. Cardboard has several advantages as a base for oil. Apart from economy, its absorbency helps a fast-working painter and subdues high-key tones. Lautrec's work on the cardboard is often in *peinture à l'essence*, a medium obtained by mixing oil paint, from which the oil has been removed by drying, with *essence*, refined turpentine, to thin it. This is easy to apply and dries quickly, qualities that appealed to Lautrec. *Alfred la Guigne* was exhibited at the Salon des Indépendants in 1894 and in London four years later.

45 *The Laundryman*
ALBI, Musée Toulouse-Lautrec. 1894. Oil on cardboard
57·8 × 46·2 cm. Signed top right.

The Hungarian painter Rippl-Rónai lived in Paris during
the 1890s and was on the fringes of the Nabi circle. In
some memoirs written in 1907 he recollected seeing
Lautrec in Gauguin's company, probably in 1894. Gauguin
was then in France for a short period, having returned
from Tahiti. The contact might explain the thicker and
more rigid contours of *The Laundryman*, with Lautrec
responding to the flat rigidity of Gauguin's previous work.

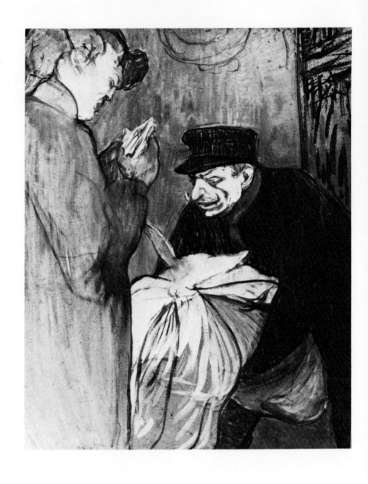

(*opposite*)
46 *Medical Inspection at the rue des Moulins*
WASHINGTON, National Gallery of Art (Chester Dale collection). 1894. Oil on cardboard
82 × 59·5 cm. Monogram bottom left.

Continuing his informal series of paintings on life in the *maisons closes*, Lautrec depicted the
prostitutes queueing for medical inspection, required in the registered brothels. There was much
publicity at the time about the scourge of syphilis, and the authorities did their best to cope with
the problem in the brothels. At the turn of the century some fourteen or fifteen percent of deaths in
France were caused by venereal diseases. The year before this picture was painted Lautrec had
lapsed, due to the marriage of Doctor Bourges, in the treatment to cure his syphilitic condition.
The woman on the left is probably Gabrielle (Plate 47). There are several oil sketches for this
painting, including two at Albi and a related one in the Musée du Jeu de Paume, Paris.

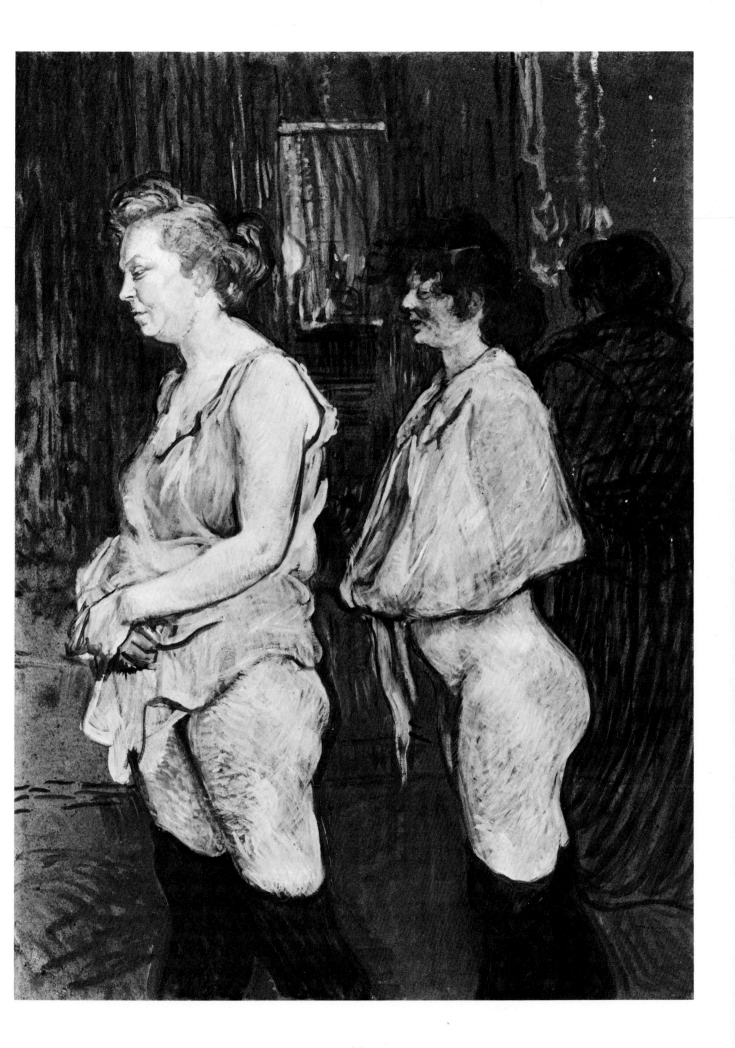

75

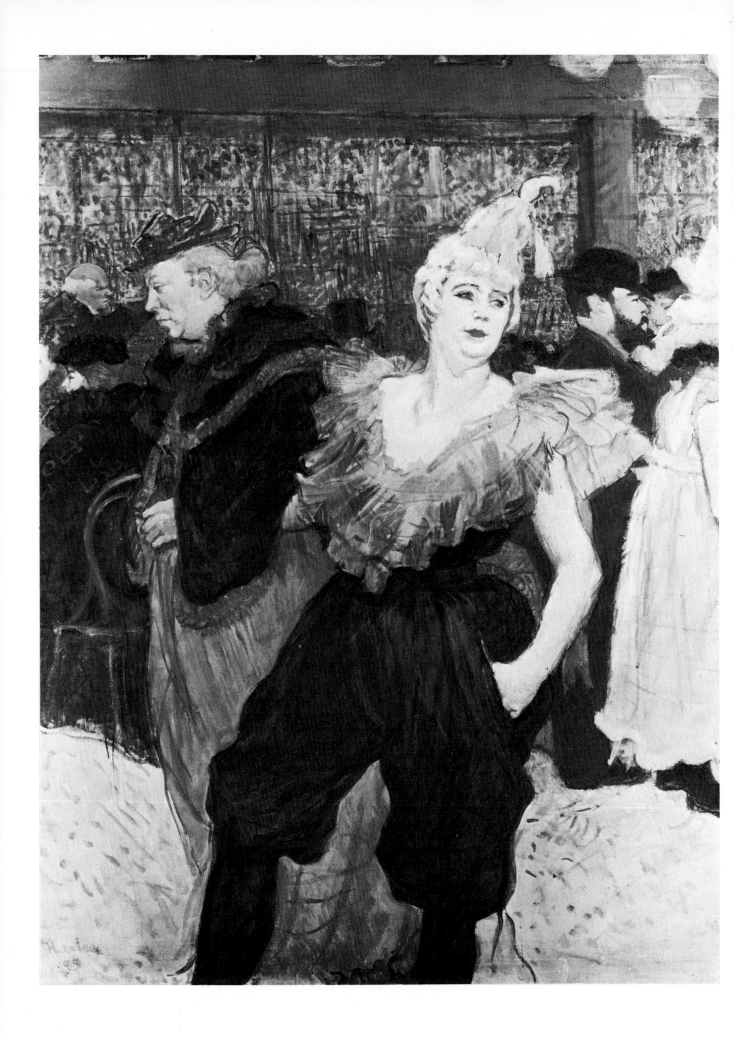

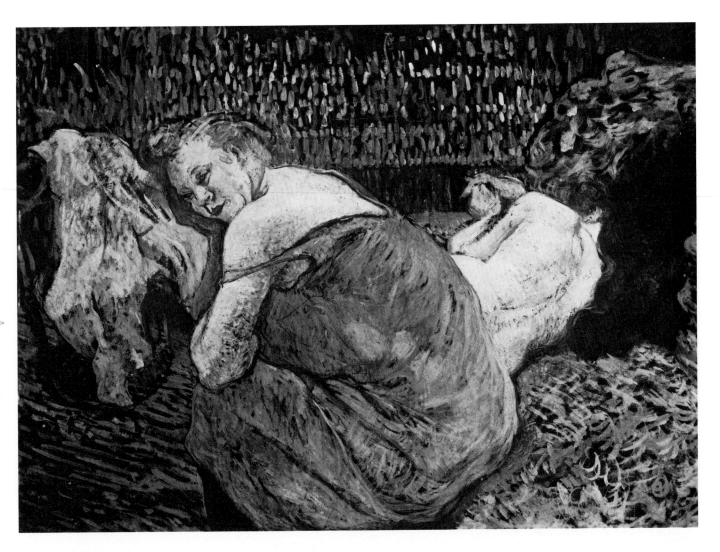

48 *Two Lesbians*
DRESDEN, Staatliche Gemäldegalerie. 1895. Oil on cardboard 60 × 81 cm. Signed and dated bottom right.

Lautrec's lesbian paintings stand in contrast to his other brothel pictures because of their generally more plausible and less schematic portrait quality. The *Two Lesbians* is a much more direct and human encounter than *The Laundryman* (Plate 45). It was exhibited at the one-man show of 1896.

(*opposite*)
47 *Cha-U-Kao at 'The Moulin Rouge'*
WINTERTHUR, Oskar Reinhart Collection 'Am Römerholz'. 1895. Oil on canvas 75 × 55 cm. Signed and dated bottom left.

Little is known about the female clown Cha-U-Kao. Her stage name was originally Chahut-Chaos, possibly a reference to her comic version of the dance, but she changed it in favour of a more Chinese-sounding one. Cha-U-Kao is accompanied here by the woman called Gabrielle la Danseuse, whose portrait was painted by Lautrec (London, National Gallery, 1891). Gabrielle also seems to appear in the *Medical Inspection* (Plate 46). Tristan Bernard (Plate 59) stands in the background. This painting was exhibited by Joyant at the 1896 one-man show and was bought by ex-King Milan of Serbia. It was reproduced by Lautrec as a colour lithograph in March 1897 (Adhémar 231). Cha-U-Kao had been the subject of one of the *Elles* prints in 1896 and that particular lithograph had sold well. Pellet, the publisher, may have asked Lautrec for another print of the same subject in response to this success, which would explain the artist's return to his painting of 1895. Lautrec painted three other oils of Cha-U-Kao, all during the brief span of his interest in her (Paris, private collection, 1895; Paris, Musée du Jeu de Paume, 1895; Cannes, Gould collection, 1895).

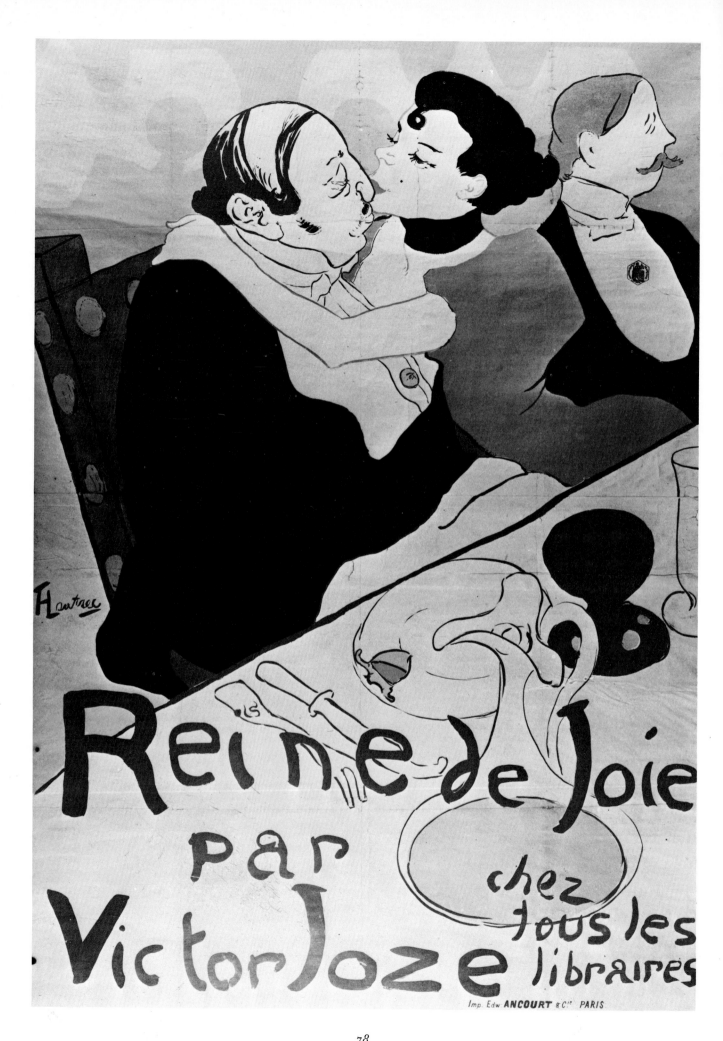

50 *A 'La Renaissance': Sarah Bernhardt as Phèdre*
PARIS, Bibliothèque Nationale. 1893. Lithograph
34 × 23·1 cm. (Adhémar 50).

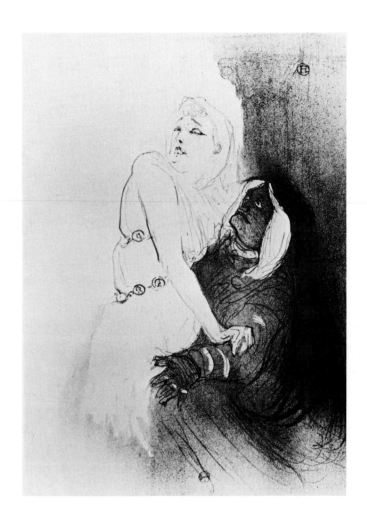

Sarah Bernhardt (1845–1923) was, by the 'nineties, the
most famous and fêted actress alive. In 1896 a municipal
Journée Sarah Bernhardt was held, with a banquet for six
hundred guests at the Grand Hôtel, menus designed by
Chéret and Mucha. After this, two hundred carriages
followed hers to her own Théâtre de la Renaissance, where
she performed, as part of her repertoire, the third act of
Racine's *Phèdre*, and her recent lover Edmond Rostand
read a poem praising her as 'Reine de l'attitude et prin-
cesse des gestes'. 'The Divine Sarah' was well aware of the
power of the poster for publicity. She commissioned them
from Orazi, Grasset, notably the *Jeanne d'Arc* of 1890, and
from Mucha, who after the success of *Gismonda* (1894)
signed a six-year contract with the actress. But she never
asked Lautrec for one, and he himself was equally dis-
interested. She represented for him, perhaps, too much the
recognized genius of the stage, too much the 'classic'
theatre, while Lautrec preferred the *maquillage* and the
vulgarity of less exalted figures. Nevertheless, he could not
resist depicting her in *Phèdre*, in the part that inspired
Proust to create La Berma, and this print was reproduced
in *L'Escarmouche* (24 December 1893). Lautrec only por-
trayed Bernhardt once again, in 1895, playing Cléopâtre
(Adhémar 166).

(*opposite*)
49 *Reine de Joie*
PARIS, Bibliothèque Nationale. 1892. Coloured poster 130 × 89·5 cm. (Adhémar 5).

Reine de Joie crisply shows the characteristics of Lautrec's poster design, the prompt arrangement of
planes into foreground, middle-ground and background, the linear simplifications and the flat
zones of colour. Lautrec, as usual, produced a preliminary compositional sketch for the lithograph
(Albi, Musée Toulouse-Lautrec), which is somewhat larger in size (152 × 105 cm.) than the final
poster. Victor Joze was the pseudonym of Victor Dobrski, a writer who had friends among painters
and who had supported Neo-Impressionism in his native Poland. In 1890 Seurat had designed a
cover for Joze's novel *L'homme à femmes*, the first occasion, in fact, on which the artist plundered
the work of Chéret, as R. L. Herbert has pointed out. The cover for *Reine de joie*, published in June
1892, was by Bonnard. The novel was about life in the *demi-monde*, forming part of a series which
Joze called *La ménagerie sociale*, and Lautrec chose to illustrate the passage in which the heroine,
Hélène Roland, kisses Olizac goodbye before he leaves Paris. Something of a scandal was caused by
the book, however, especially in banking circles. Baron de Rothschild suspected the novel's hero,
baron de Rosenfeld, was modelled on himself, and he was further irritated by Joze's supposed
anti-Semitism. Perhaps due to Rothschild's machinations, young stockbrokers ripped the poster
down from the walls of Paris and the prefect of police had to be called in when two bill-stickers
were bribed not to do their job. Frantz Jourdain, an architect and friend of Lautrec, certainly saw
the poster in terms of a gibe at the vices of the rich. In *La Plume* (15 November 1893) he wrote,
'The aged, overblown prostitute, loved for her licentiousness and squalour, sprawls in an abject and
shameless manner in the embrace of a pot-bellied banker, who is clearly as wealthy as he is shady.
How admirably drawn too is the doddering, lewd old man who pays a woman of the town to
plant a kiss on his worn, flabby cheeks.' Taking this incident from the novel Lautrec brought up to
date the traditional imagery of the old man bargaining for the sexual favours of a young girl,
imagery to be found in Baldung, Cranach or Jordaens, later in Beckmann and Otto Dix. The men
were posed by M. Lasserre on the left and M. Luzarche on the right; the girl is unknown. Lautrec
later executed a cover for Joze's *La tribu d'Isidore* (1897, Adhémar 235) and a poster for *Babylone
d'Allemagne* (1894, Adhémar 67, 68).

51 *The Fainting-spell*
PARIS, Bibliothèque Nationale. 1894. Lithograph
37·5 × 27·9 cm. (Adhémar 61).

Only a few copies were printed of this lithograph. It
represents Lugné-Poë and Baldy in a play called *L'Image,*
by Beaubourg, at the Théâtre de l'Oeuvre, of which
Lugné-Poë was also the director. At this time Lautrec
was providing theatre drawings for the newspaper
L'Escarmouche, and his publisher Kleinmann would later
produce these drawings as lithographs. *The Fainting-spell*
itself, however, was not printed in *L'Escarmouche.*

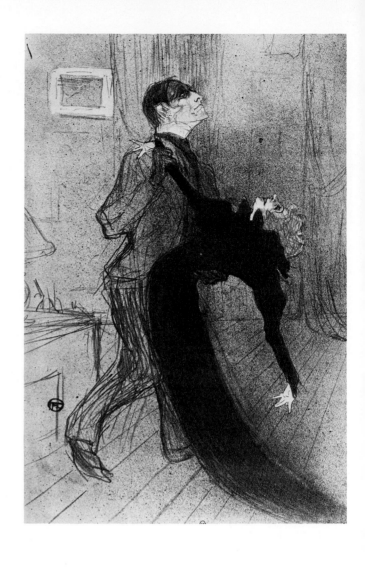

(*opposite*)
52 '*Le Divan Japonais*'
PARIS, Bibliothèque Nationale. 1893. Coloured poster 130 × 94 cm. (Adhémar 11).

During the 1860s a particularly Parisian form of entertainment appeared as if from nowhere, the
café-concert. Known colloquially as the "caf'-conc' ", it was a casual fusion of café and theatre,
where one could sit and meet friends, drink and watch an act on the stage, usually a singer or
dancers. The theatre seats had a shelf on their backs on which the row behind could rest their
glasses, and waiters wandered among the audience taking orders, so the performers rarely had
quiet. The songs were frequently bawdy, witty, frivolous, light entertainment. After 1890 Lautrec
began to visit the café-concerts more and more, rather than the straightforward dance-halls like
The Moulin de la Galette. In them he found the performers whom he enjoyed and whom he could
watch on stage in a congenial atmosphere, not among a pell-mell of dancers. The next step for him
was, of course, the boulevard theatres. Le Divan Japonais was a scruffy establishment, probably
named after its bogus oriental décor; the musicians, for example, wore Japanese costumes. Yvette
Guilbert described it: 'Imagine at the top of the rue des Martyrs a little place like a provincial
café, with a low ceiling, which could take at a push a hundred and fifty or two hundred people.'
Although this poster was Lautrec's only professional link with this café-concert, many of his friends
and acquaintances were *habitués,* the illustrators Willette, Steinlen, Forain and Léandre, older
painters like Desboutin, Raffaëlli, Roybet and Détaille, the writer Catulle Mendès and Bruant. '*Le
Divan Japonais*' shows Jane Avril and Dujardin watching Yvette Guilbert, identifiable by her lanky
figure and black gloves. Like *Reine de Joie* (Plate 49), the poster is divided into three planes, here
stage, orchestra and audience. The muted harmony of pale yellow and grey is dominated by the
crisp blackness of Jane Avril's dress and the two hats; a quarter of the picture surface is printed in
plain black. The frontal plane is firmly established by this expanse and by the profiles and rhythmic
drawing of the two spectators. Behind them diagonals fix the orchestra pit, crossed by the heads of
two double-basses and the conductor's arms, which lead towards Yvette Guilbert's head,
sardonically cropped by the upper edge.

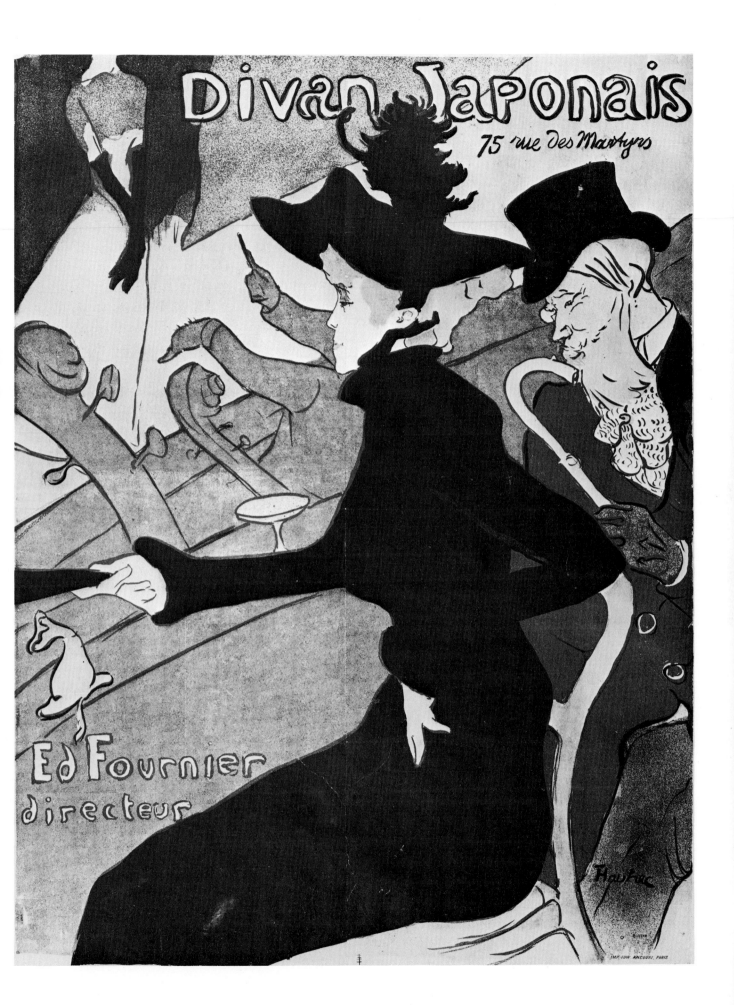

53 *Yvette Guilbert*
ALBI, Musée Toulouse-Lautrec. 1894. Charcoal and essence
on paper 186 × 93 cm. Unsigned.

This huge drawing is a study for an unfinished poster. The
project probably came to nothing because the artiste or
her friends objected to Lautrec's portrayal. She herself
sent him a note in July 1894, 'For the love of heaven,
don't make me so appallingly ugly! Just a little less so! So
many people who saw it here shrieked with horror at the
sight of your coloured sketch.' Yvette Guilbert (1867–1944)
had a long and celebrated stage career that began at The
Jardin de Paris and The Moulin Rouge. Her act featured
monologues and songs, many written by Maurice Donnay,
delivered in a novel manner. 'She has made herself the
muse of dry sarcasm, the exponent of a curious form of
humour, morose and ingenuously immoral,' wrote Georges
Montorgueil in the *Echo de Paris* of 9 December 1893.
Her costume was calculated for effect, with her long
black gloves and low-cut dress accentuating her sparse
figure. Here Lautrec concentrated on the face that so
fascinated him, exaggerating the diseuse's expressive
features, with her straw-coloured hair, blue mascara and
red lips and making her face the cynical summary of its
own expressive plasticity. But if Yvette disliked her
portrayal by Lautrec she also turned down the offer of
a portrait by Burne-Jones, saying that she had too many
of herself.

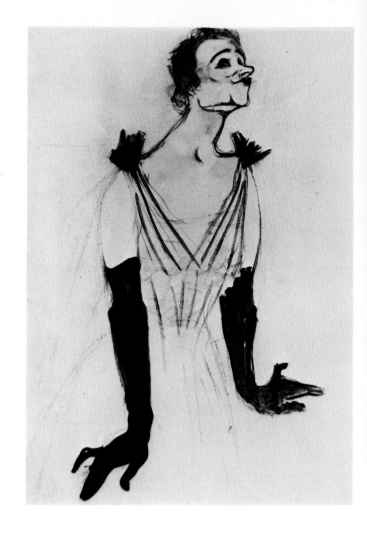

(*opposite*)
54 *Yvette Guilbert*
MOSCOW, Pushkin Museum. 1894. Oil on cardboard 58 × 44 cm. Signed, dated and dedicated
bottom left: à Arsène Alexandre.

Lautrec never painted a formal portrait of Yvette Guilbert in oil. This particular image of her,
singing the famous 'Linger Longer Loo', is a study for an illustration published in *Le Rire* (22
December 1894). The diseuse posed specially for the illustration, and Lautrec gave this study to
Arsène Alexandre (1859–1937), art editor of the magazine and supporter of the artist. The pose
in this sketch of Yvette is close to one in the album of lithographs that Lautrec dedicated to her in
the same year. With a text by Gustave Geffroy and sixteen plates, the album appeared at the
beginning of August. According to Adhémar, it had a *succès de scandale*, defended in some reviews,
such as that in *La Vie Parisienne*, and vilified elsewhere. It was attacked for its deification of a
popular artiste and also for its deformation of her features. Jean Lorrain, who hated Lautrec and
later used him as a model for the sadistic painter Ethal in the novel *Monsieur de Phocas* (1901),
lamented that the artist's current taste for green lithographic ink made Yvette seem drawn in
'gooseshit'. Lautrec produced another album of lithographs in 1898, when the English publishers
Bliss and Sands commissioned eight plates on Yvette Guilbert.

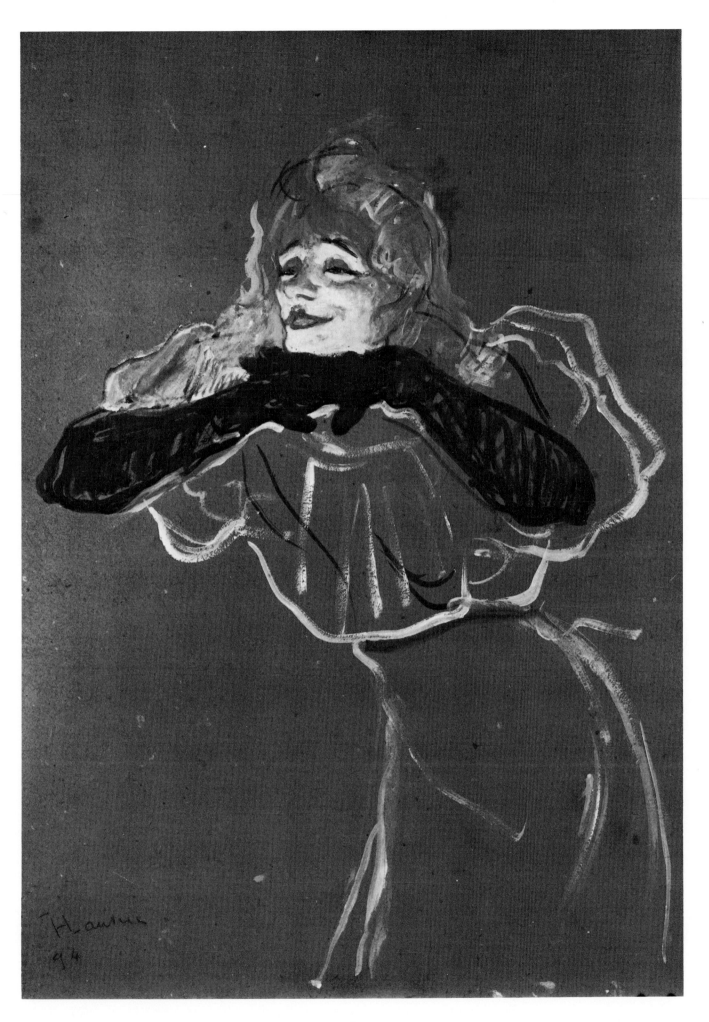

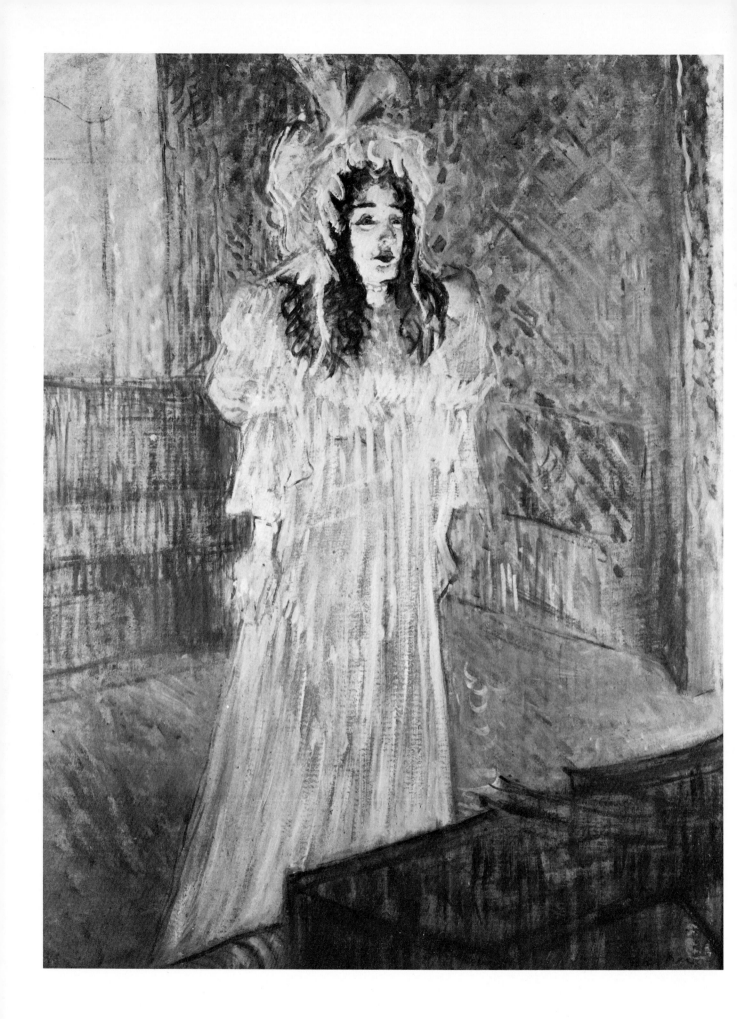

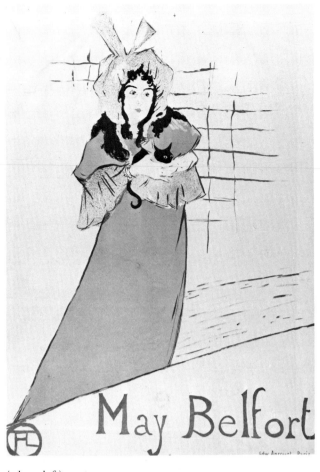

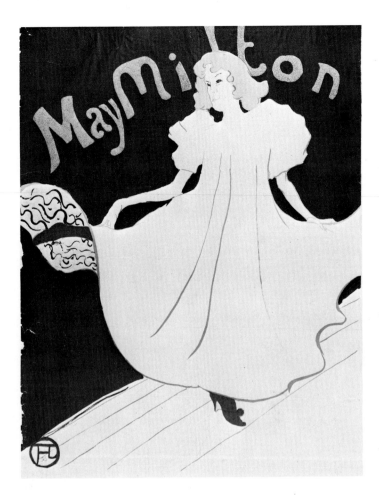

(*above left*)
56 *May Belfort*
PARIS, Bibliothèque Nationale. 1895. Coloured poster 78·8 × 60 cm. (Adhémar 116).

Lautrec first noticed May Belfort early in 1895 when he went to see Jane Avril at The Décadents café-concert, 16 bis rue Fontaine. As well as this poster, he made several lithographs of the Irish girl in the same year (Adhémar 118–122 and 124). Although Lautrec called her 'the orchid', Joyant, his school-friend, dealer, intimate and biographer, called her 'the frog'. Like the poster for May Milton (Plate 57), with which Lautrec meant it to be paired, *May Belfort* is a direct presentation, reticent with the accessories.

(*above right*)
57 *May Milton*
PARIS, Bibliothèque Nationale. 1895. Coloured poster 78·5 × 59·7 cm. (Adhémar 149).

One hundred copies were printed of this poster, which was commissioned for a tour by May Milton of the United States. It was reproduced in *Le Rire* of 3 August 1895. May Milton, an Englishwoman, performed as a dancer and cabaret entertainer. Lautrec became friendly with her in 1895 for a short period, at the same time as his interest in her friend May Belfort, taking them both to the Irish-American Bar. One of Lautrec's sparsest posters, *May Milton* is reliant on the single figure, with minimal description of space or setting. This seems to have appealed to Picasso, who included the poster in his painting *La Toilette* of 1901 (Washington, Phillips Collection).

(*opposite*)
55 *May Belfort*
CLEVELAND, Cleveland Museum of Art (bequest of Leonard C. Hanna, Jr.). 1895. Oil on cardboard 63 × 48·5 cm. Signed bottom right.

In 1895 the Irish singer May Belfort was the focus of one of Lautrec's shortest but most fanatical enthusiasms. She appeared at a number of café-concerts, The Eden-Concert, The Jardin de Paris, The Décadents and The Parisiana, clothed in pastel-coloured dresses in a Kate Greenaway style, clutching a cat and singing:

> I've got a little cat,
> And I'm very fond of that . . .

Painting her in front of the foot-lights Lautrec caught her little-girl-lost persona, but offstage May Belfort was far from innocent. She had a lesbian relationship with May Milton, another café-concert performer, and Lautrec cheekily used a similar format for the posters he designed for each of them (Plates 56 and 57).

58 *Marcelle Lender*
LONDON, British Museum, Department of Prints and Drawings. 1895. Black lead and black chalk 33 × 22·2 cm. Monogram bottom right.

Marcelle Lender (1869–1927), an actress admired for her talent and beauty, made her name at the Théâtre des Variétés. Lautrec had first noticed her in 1893, when he produced the lithograph *Lender and Baron* (Adhémar 46). This drawing may have been an early idea for the print, as it shows the actress in a similar pose and dress, but there is greater likelihood that it dates from 1895, the period of Lautrec's most concentrated attention on Lender, and the finished quality of the drawing might suggest that it was a preliminary study for a bust-length portrait. *Marcelle Lender* once belonged to Théo van Rysselberghe, the Belgian Neo-Impressionist painter who had been one of the very first to recognize Lautrec's talent. In 1887 van Rysselberghe, as adviser to Les XX in Paris, had recommended Lautrec as a future exhibitor, securing him his first showing in an organized public exhibition. With Joyant, Dethomas and Tapié, van Rysselberghe also helped to organize the retrospective of Lautrec's work held at La Libre Esthétique in Brussels in 1902.

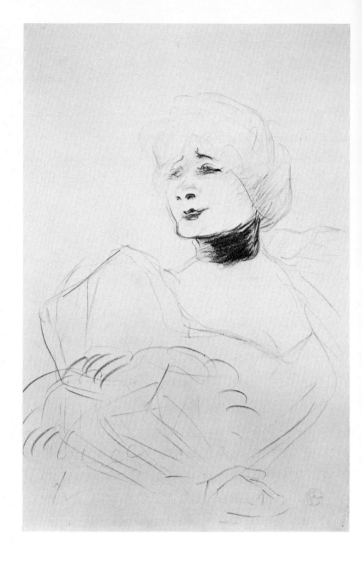

(*opposite*)
VIII *Aux 'Ambassadeurs'*
PARIS, Bibliothèque Nationale. 1894. Coloured lithograph 30·2 × 24·6 cm. (Adhémar 73).

One hundred copies of this lithograph were printed for *L'Estampe originale*, a collectors' publication that issued three portfolios a year between 1893 and 1895. A subsidiary, under the direction of Roger Marx and André Marty, of *Le Journal des artistes*, *L'Estampe originale* included prints by Bonnard, Vuillard, Redon, Renoir, Whistler, Rodin, Puvis de Chavannes and Gauguin, as well as Lautrec. The flat and ordered passages of colour in Lautrec's print bring it closer to the work of the Nabis than to work of comparable subjects of the earlier generation, for instance, Degas's lithograph *Mademoiselle Bécat aux 'Ambassadeurs'* (c. 1877–79), another image of a singer performing at this café-concert.

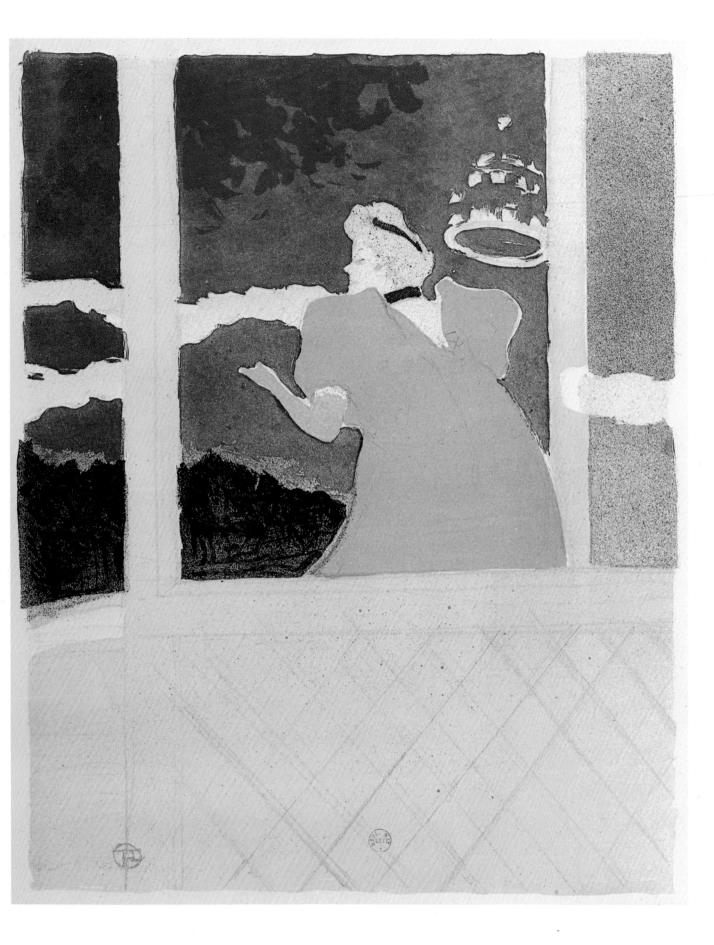

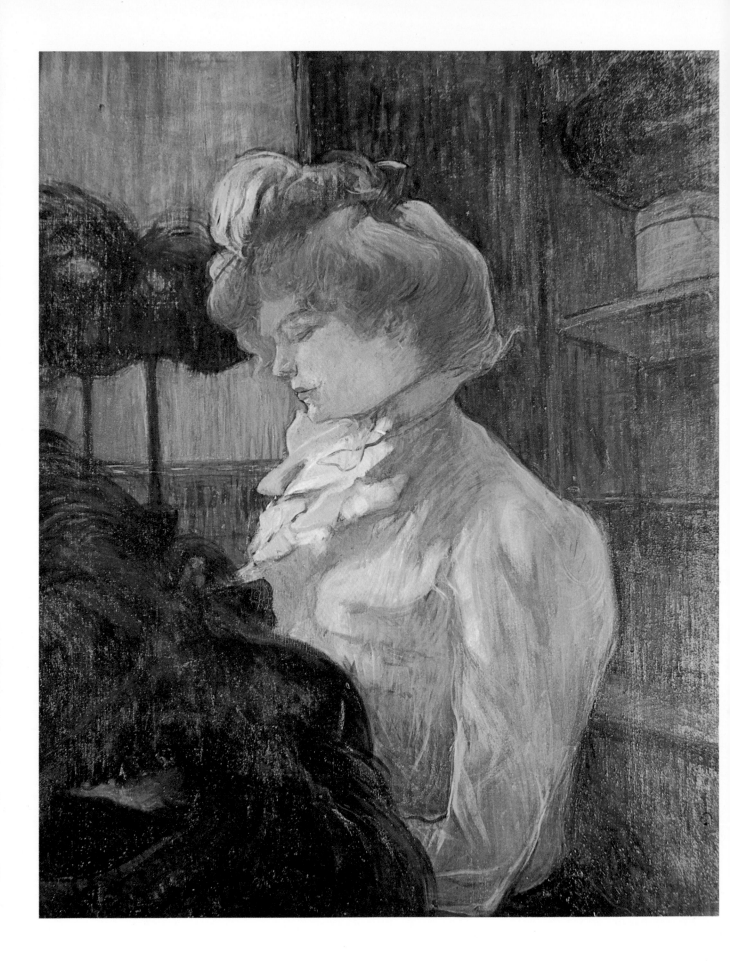

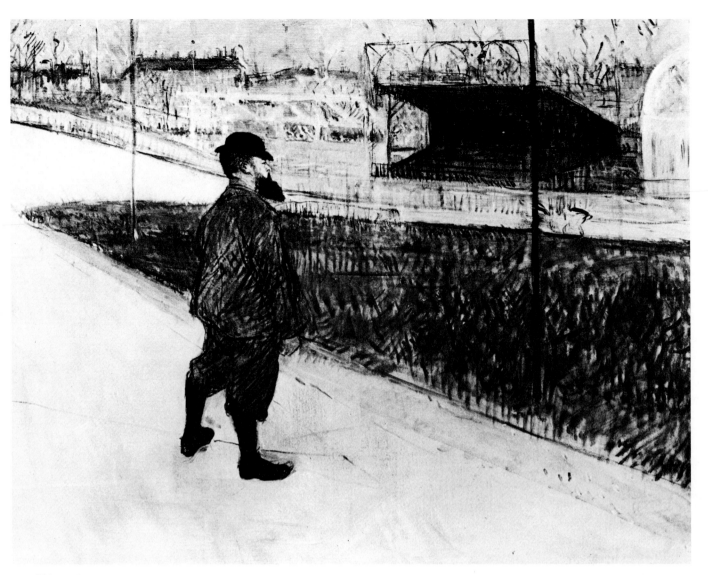

59 *Tristan Bernard at the Buffalo Stadium*
NEW YORK, private collection. 1895. Oil on canvas 64·5 × 81 cm. Unsigned.

One of the *Revue blanche* circle, Tristan Bernard (1866–1947) had an eccentric career as industria-
list, lawyer, journalist and playwright. He was a close friend of Lautrec and introduced the painter
to the fashionable enthusiasm for bicycling. The cycle was the rage of the mid-1890s. Jarry wrote
an hilarious short story entitled *The Passion Considered as an Uphill Bicycle Race,* Forain was president
of the Artistic Cycle Club, and the young Vlaminck earned his living as a racing cyclist. Bernard
held posts as both the director of the Buffalo Stadium at Neuilly and editor of the *Journal des
vélocipédistes.* Lautrec emphasized Bernard's virile and athletic stance as he surveys the race-track,
an unusual outdoor motif for the artist which he probably painted from memory. Lautrec greatly
enjoyed the cycling scene. In 1896 he made two posters for bicycle chains (Adhémar 184, 187), and
one, *La Chaîne Simpson,* he showed at the Rheims poster exhibition that year.

(opposite)
IX *The Milliner*
ALBI, Musée Toulouse-Lautrec. 1900. Oil on panel 61 × 49·3 cm. Signed top right.

Lautrec's friends attempted to curb his drinking in the last months of his life by encouraging his
interests and hobbies, one of which was fashion, fine materials and clothes. Manet's comrades had
tried much the same therapy to distract him from his illness some twenty years before. Opinions
are divided as to the identity of the milliner. She was either Louise Blouet, who worked for the
modiste Renée Vert, or Renée Vert herself. Huisman and Dortu follow Joyant in favouring the
former, while Cooper and Jourdain opt for the latter. The figure is established in depth by hats
both behind and in front of her. Lautrec's re-animated concern for light becomes particularly
noticeable in the return towards chiaroscuro modelling, which fuses well with the rather sinister
colouring and pinched drawing of her features.

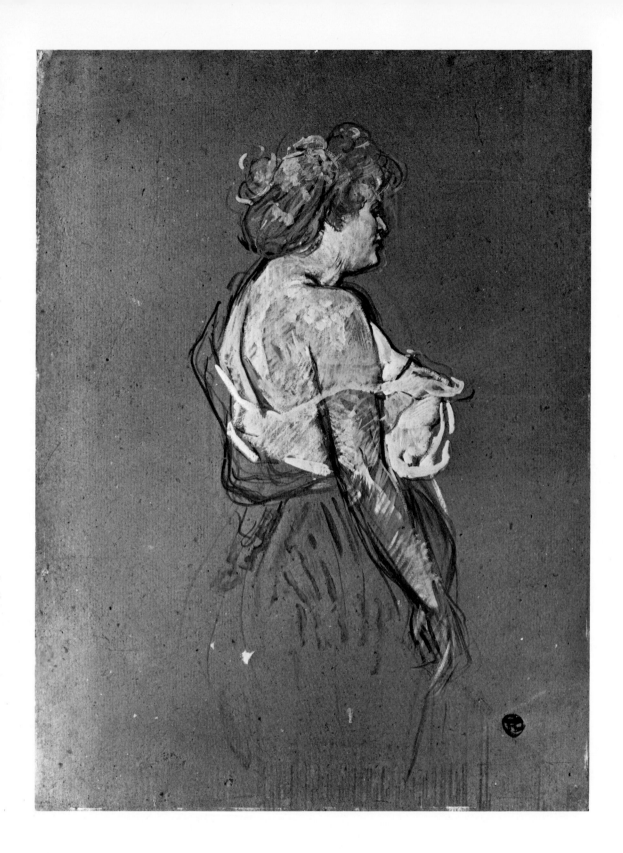

60 *Lucie Bellanger*
ALBI, Musée Toulouse-Lautrec. 1896. Oil on cardboard 80·7 × 60 cm. Monogram bottom right.

In this sketch, one of Lautrec's most forceful works, the powerful drawing of neck and shoulder and the jutting of the breast are quietened by the loose calligraphy of the yellow hair and green skirt. The three-quarter length format suited Lautrec; he could establish character by contours derived from the head and torso while stabilizing the whole figure with the bottom edge. The model was a prostitute.

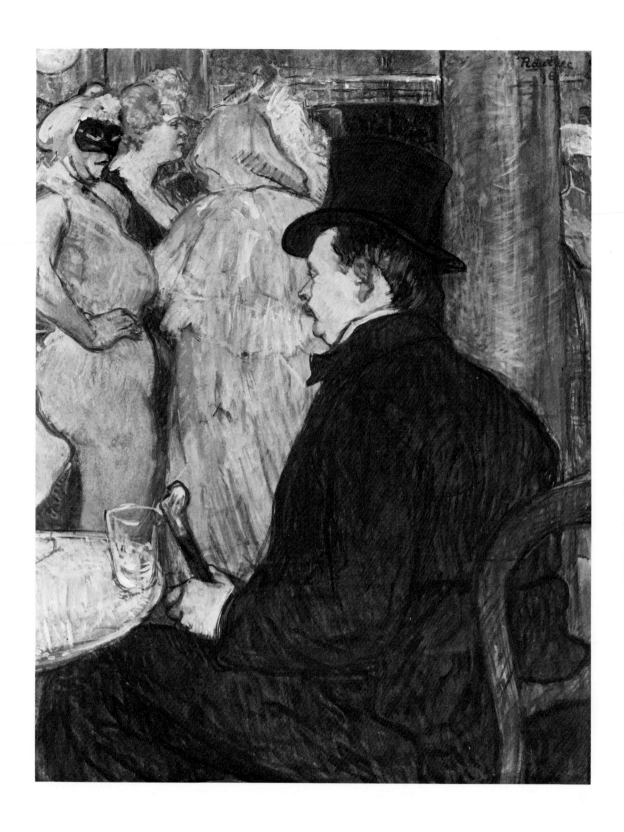

61 *Maxime Dethomas at the Opera Ball*
WASHINGTON, National Gallery of Art (Chester Dale collection). 1896. Oil on cardboard
68 × 52·5 cm. Signed and dated top right.

Lautrec's portrait of Dethomas is a compositional refinement on an earlier painting, *M. Delaporte
at 'The Jardin de Paris'* (Copenhagen, Carlsberg Glyptotek, 1893). In both pictures Lautrec
balanced the bulk of a man seated in the right foreground with greater depth to the left. But in the
Dethomas portrait the figure is more successfully integrated with the environment in an anecdotal
sense. Dethomas (1868–1928) was a painter and stage-designer. Much bigger than Lautrec, who
called him 'Grosn'arbre', Dethomas belonged to the group of close friends who were dominated by
Lautrec and yet protected and cared for him. Paul Leclercq remembered that Lautrec was parti-
cularly fascinated by Dethomas's knack of remaining impassive in all circumstances, and this
portrait of Dethomas, calm in face of the sexually provocative stance of the woman beyond him,
catches this characteristic.

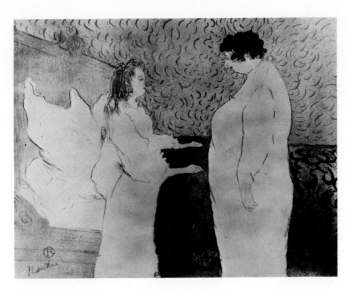

(*above left*)
62 *Woman in Bed*
PARIS, Bibliothèque Nationale. 1896. Coloured lithograph 40 × 52 cm. (Adhémar 208).

In 1896 the publisher Pellet commissioned an album of lithographs from Lautrec, the famous *Elles* series. The ten lithographs in addition to a cover deal with life in the brothel, a subject which Lautrec had abandoned by 1896 and might not have treated again had he not been offered the commission. Yet, as Adhémar has pointed out, only the first and penultimate prints in the series suggest the *maison close*. The models were Guibert's mistress Mlle. Popo and her mother Mme. Baron, as well as a large woman mainly seen washing herself. Only five of the album are coloured lithographs, the rest having been printed in black-and-white on plain or tinted paper. The *Woman in Bed* emphasizes the flat patterning effects used by Bonnard and Vuillard at this time and stands in contrast to *Woman with a Tray* (Adhémar 202), for which the same models posed. In *Elles* Lautrec almost catalogued his different lithographic styles.

(*above right*)
63 *Sleep*
ROTTERDAM, Boymans-van Beuningen Museum. 1896. Sanguine on blue paper 37 × 48 cm. Signed bottom right.

Sleep is a preliminary drawing for a lithograph of the same title (Adhémar 211). This print is related in style to some of the *Elles* series, although it is not part of the album. Both drawing and lithograph show how, by 1896, Lautrec occasionally could return to a less schematic and more sculptural, even more academic, style of drawing. This renewed discipline also found its way into his painting (Plate 69). Rachou, a painter and a friend of Lautrec, once owned this sheet.

(*opposite*)
64 *A Passing Fancy*
TOULOUSE, Musée des Augustins. 1896. Oil on canvas 103 × 65 cm. Signed bottom left.

Also known as *Conquête de Passage*, this canvas is a painted version of one of the *Elles* lithographs (Adhémar 209). The painting has a sense of muscular pose lost to both figures, especially the man, in the print. Perhaps a memory of Manet's infamous *Nana* (Hamburg, Kunsthalle, 1877) might have prompted Lautrec to adopt this subject; he could have seen *Nana* at the Manet sale of 1884 or, more plausibly, at the exhibition of Manet's work held by Durand-Ruel in 1896. A very similar pose to Lautrec's female model can be found in Vuillard's *Model in the Studio* (Fort Worth, Kimbell Art Museum, c. 1905–06). The man was posed by Charles Conder.

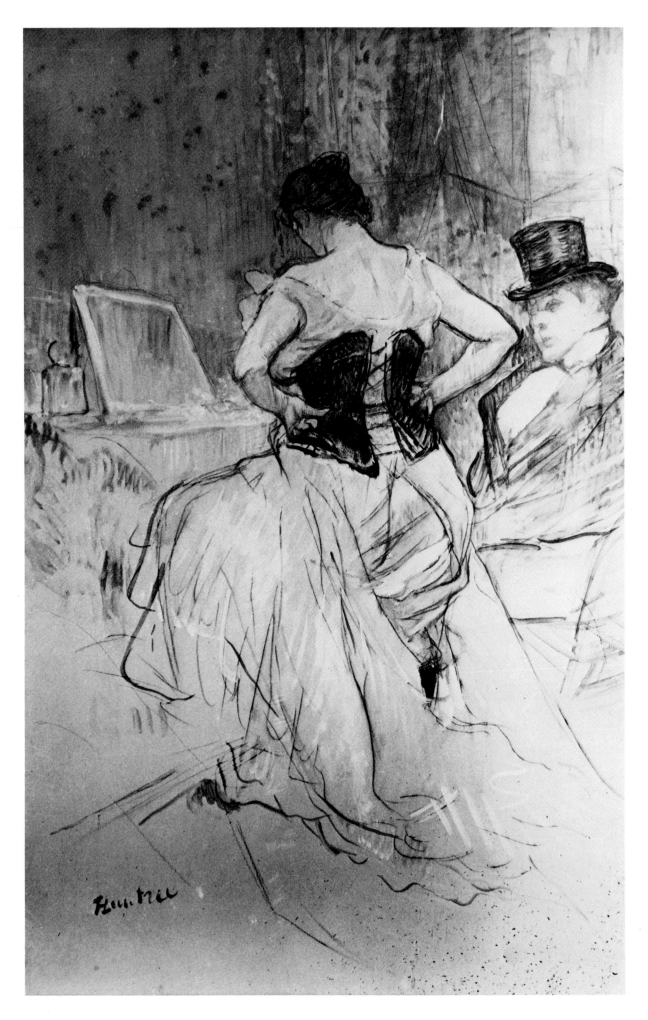

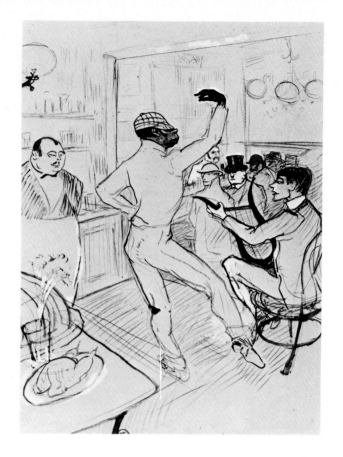

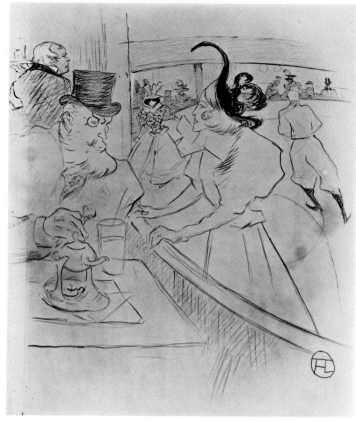

(above left)

65 *Chocolat Dancing*

ALBI, Musée Toulouse-Lautrec. 1896. Blue crayon, Chinese ink and white gouache 65 × 50 cm. Monogram bottom left.

Chocolat was a black from Bilbao who performed a famous double act with his fellow clown Footit. An Englishman, Footit (1864–1921) was drawn on several occasions by Lautrec, notably in the illustrations for Coolus's article of 1895, published in *Le Rire*, *Footit's Theory of Rape*. Chocolat performed in black trousers and a red shirt, and, when his act was finished, he would leave The Nouveau Cirque for the bar depicted in this drawing. The Irish-American Bar in the rue Royale, run by a man called Achille, was one of Lautrec's favourite haunts when he moved to the more sophisticated centre of the city. As the name implies, Achille's bar was much frequented by English-speaking customers and this attracted Lautrec, always eager in his anglomania. Chocolat, watched by the barman Ralph and baron de Rothschild's top-hatted coachman Tom, is seen dancing in the bar and singing 'Sois bonne, ô ma chère inconnue'. By the mid-1890s Lautrec's line had a much more consistent suppleness than before, apparent in the contrast of Chocolat and his admirers with Valentin and the others in *The Dance at 'The Moulin Rouge'* (Plate 22). *Chocolat Dancing* uses blue crayon, common in Lautrec's drawing at this time, but when published in *Le Rire* (28 March 1896) it was reproduced in woodcut, with a lithographic tint.

(above right)

66 *Skating Professional Beauty*

PROVIDENCE, Rhode Island School of Design, Museum of Art (gift of Mrs. Murray S. Danforth). 1896. Blue and black crayon and wash heightened with white on beige paper 71 × 56 cm. Monogram bottom right.

Liane de Lancy, the courtesan after whom Lautrec titled this drawing, was 'Queen of Skating' at The Palais de Glace in the Champs-Elysées. She chats with Edouard Dujardin (1861–1949), the music and literary critic and author of *Les lauriers sont coupés* (1887), a novel which opened up the possibilities of the interior monologue later explored by Joyce in *Ulysses*. Dujardin appears in a number of Lautrec's works, notably *At 'The Moulin Rouge'* (Plate V) and the poster for Le Divan Japonais (Plate 52). This drawing was printed on the back cover of *Le Rire* (18 January 1896), Lautrec's treatment rendering it easy for reproduction, with the emphasis on contour and not internal modelling. Skating had become fashionable in the 1870s. Jules Claretie, writing in 1882, noted that 'skating, practised seriously in England where it is regarded as a useful institution, has become in France merely a variant of the café-concert.' Manet had painted *Skating* in 1877 (Cambridge, Massachusetts, Fogg Art Museum), and Bonnard followed in 1898 with *At 'The Palais de Glace'* (Berne, collection of Hans R. Hahnloser). Lautrec had used the ice-rink for motifs in 1895, the year before *Skating Professional Beauty*. The poster that he made for *La Revue blanche* in that year showed Thadée Natanson's wife Misia skating, and another lithograph may have been an experiment for a Palais de Glace programme (Adhémar 115, 136).

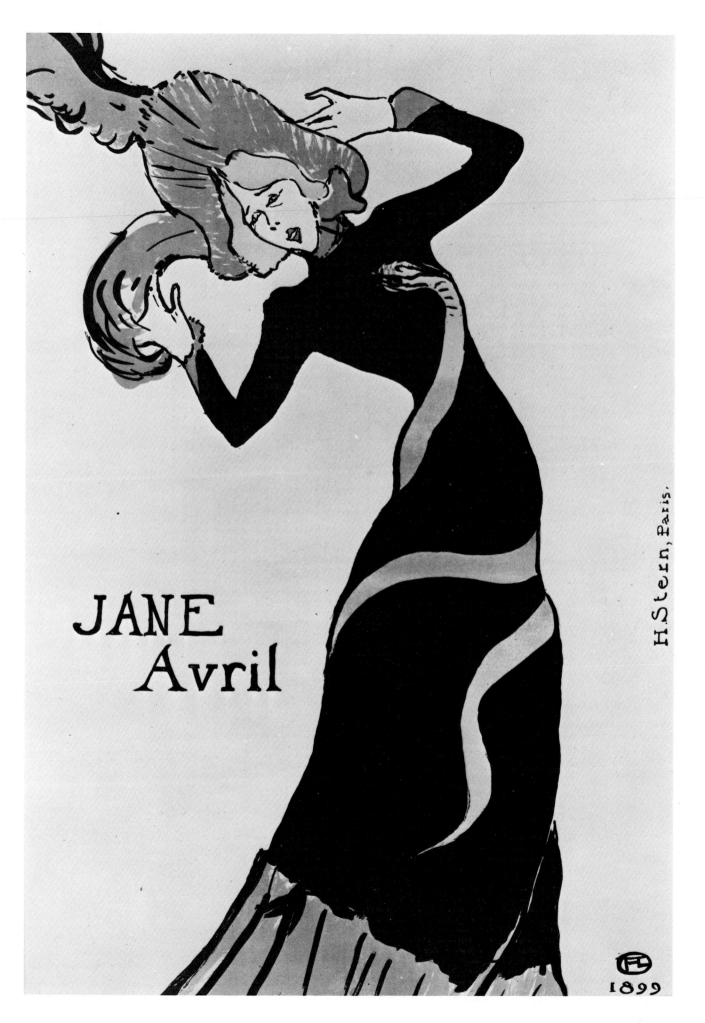

JANE
Avril

H.Stern, Paris.

1899

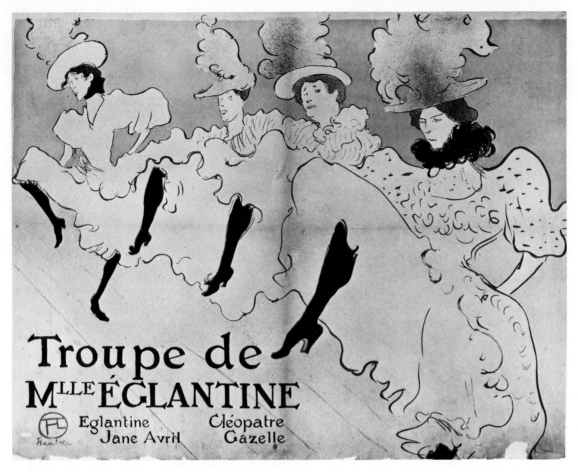

68 *Mlle. Eglantine's Troupe*
PARIS, Bibliothèque Nationale. 1896. Coloured poster 61·5 × 80 cm. Monogram bottom left
(Adhémar 198).

This poster was commissioned from Lautrec by Jane Avril. Her letter of request in the Musée
Toulouse-Lautrec, Albi insists on the ordering Lautrec gave in the lettering: Eglantine, Jane Avril,
Cléopâtre, Gazelle. But the artist seems to have broken this order in the line of figures, for the
dancer to the furthest left of the poster is surely Jane Avril. The poster was to advertise the troupe's
tour of England. Mack records that the trip to London was made in 1897, but that the tour failed
because a clash of temperaments divided Jane Avril and Eglantine from the other two dancers.
The poster was reproduced in *Le Courrier Français* of 16 February 1896.

(preceding page)
67 *Jane Avril*
PARIS, Bibliothèque Nationale. 1899. Coloured poster 56 × 36 cm. (Adhémar 323).

In 1899 Jane Avril commissioned a poster from Lautrec, sympathetic to his difficulties and grateful
for his depictions of her in the past; she considered that she owed her success to him. In the event,
the poster was never used. The dancer is seen in the standing pose, bent from the waist, that
Lautrec liked and took up again and again in the large paintings of around 1890. Her hat, plumes,
scarf, cuffs and flounce are all scarlet, and her black dress is decorated by a yellow and blue cobra
which coils its way up her body, a metaphor of her performance which was by no means
inappropriate but which was considered too bizarre. Lautrec's acquaintance, the eccentric writer
Alfred Jarry, also extremely short and also an alcoholic, seems to have admired one of Lautrec's
posters of Jane Avril. In his farcical novel *Gestes et opinions du docteur Faustroll 'pataphysicien*,
published posthumously in 1911, the bailiff Panmuphle confiscates from Faustroll's house 'three
prints hanging on the walls, a poster by TOULOUSE-LAUTREC, *Jane Avril*; one by BONNARD,
advertising the *Revue Blanche*; a portrait of Doctor Faustroll, by AUBREY BEARDSLEY'.

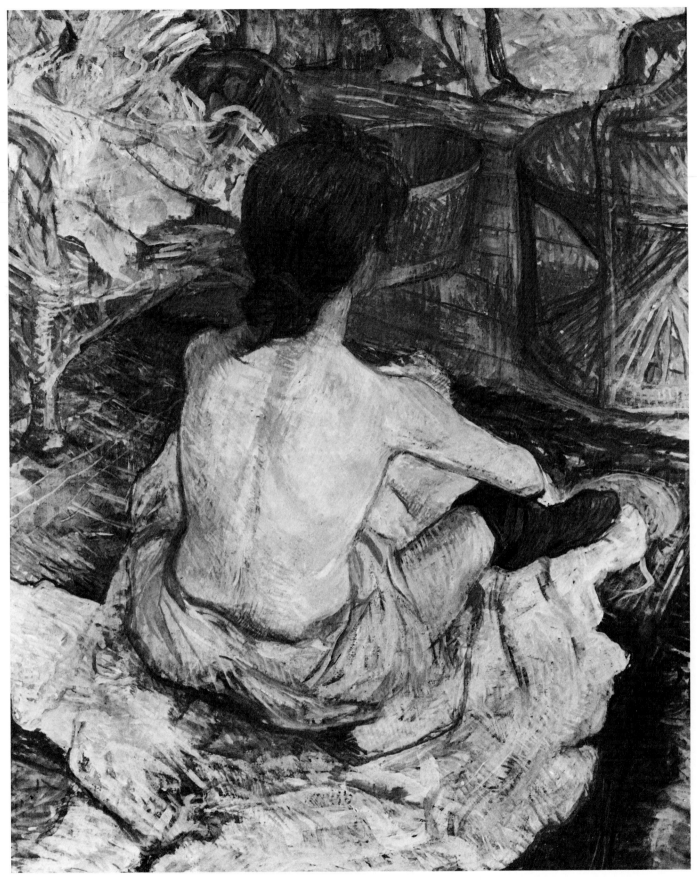

69 *La Toilette*

PARIS, Musée du Jeu de Paume. 1896. Oil on cardboard 64 × 52 cm. Signed bottom right.

One of a number of nude studies painted in this year, *La Toilette* continued the disciplined drawing and studious naturalism characteristic of the group as a whole and of this period in Lautrec's career. Lautrec preferred women with red hair, like the unknown model for this fine oil. Using a favourite figure of speech in his clipped Gascon accent, he would talk of red hair as 'teknik des Vénétiens'.

(*above left*)
70 *New Year's Greeting*
PARIS, Bibliothèque Nationale. 1897. Lithograph 25 × 22·2 cm. (Adhémar 271).

This print, intended merely for the moment, shows Lautrec at his most tongue-in-cheek. A client, a bourgeois gentleman, greets a prostitute, whose breasts bulge out of her dress below the cross she wears around her neck. The ritual is watched by the artist himself, perched on a stool, naked and out of scale, and is captioned by ironic greetings of the season.

(*above right*)
71 *At 'La Souris'*
ALBI, Musée Toulouse-Lautrec. 1897. Lithograph 35·9 × 25·2 cm. (Adhémar 252).

About 1896 Lautrec began to haunt two bars, La Souris and Le Hanneton, both lesbian rendezvous. He preferred the former to Mme. Brazier's Le Hanneton. Mme. Armande Palmyre was the fat proprietress of La Souris and the owner of the bulldog that appears in several of Lautrec's prints at this time. The stern looking women and a comparatively anonymous man are ranged along the wall of the bar with their heads in profile, seated on one arm of the 'L' shaped composition.

(*opposite*)
72 *The Chestnut-vendor*
PARIS, Bibliothèque Nationale. 1897. Lithograph 25·8 × 17·5 cm. (Adhémar 254).

Adhémar has redated this print on the evidence of Mme. Palmyre's bulldog. Delteil had preferred the date of 1901. *The Chestnut-vendor* is an unusual subject for Lautrec, who tended to leave working-class themes to contemporaries like Steinlen or Raffaëlli.

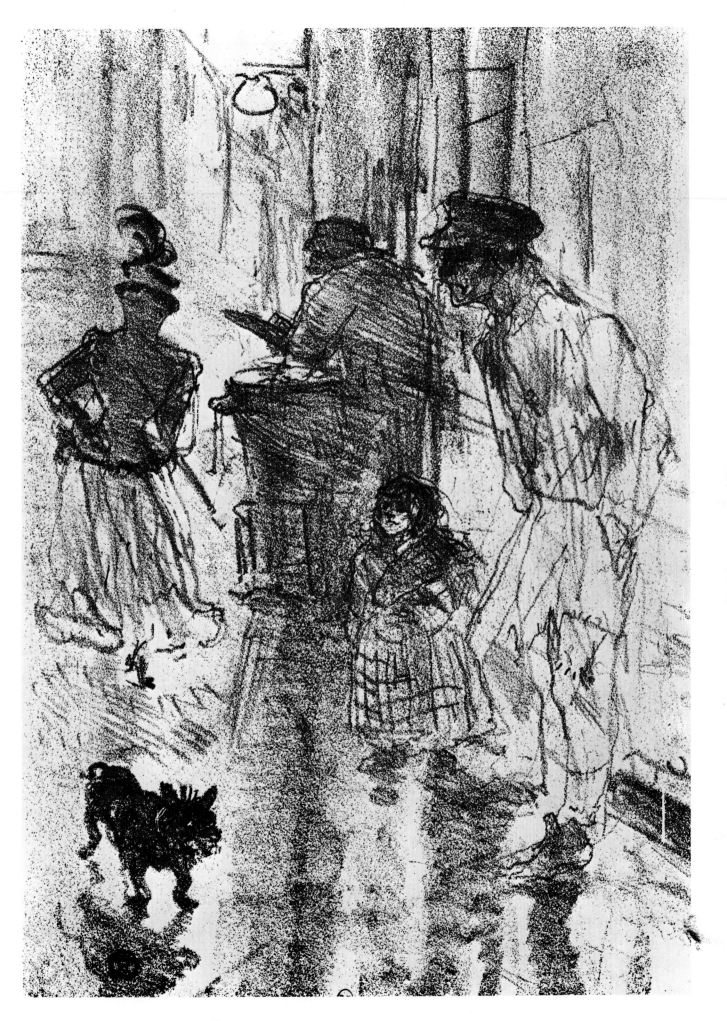

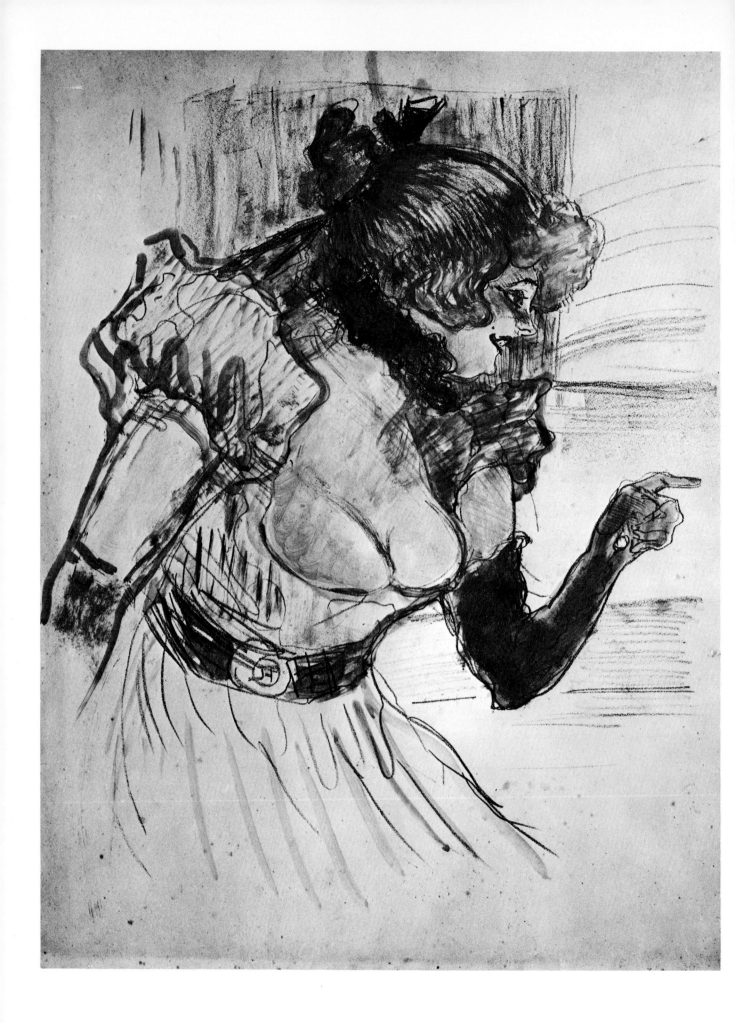

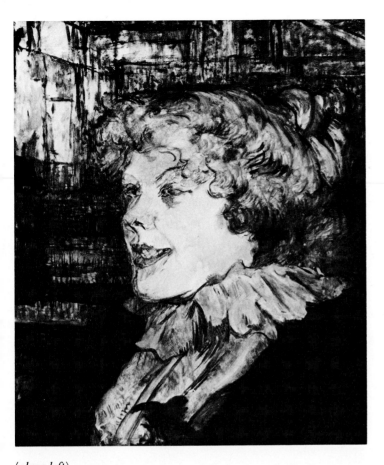

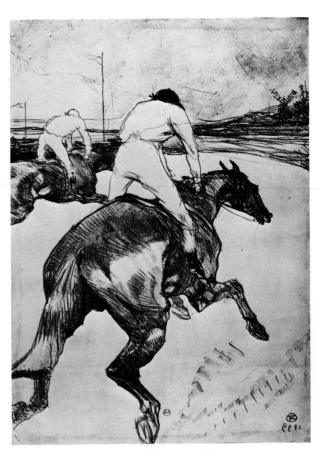

(above left)

74 *The English Girl from 'The Star', Le Havre*

ALBI, Musée Toulouse-Lautrec. 1899. Oil on panel 41 × 32·8 cm. Signed and dated top right and bottom left.

The Star was a sailors' bar in the rue du Général Faidherbe, Le Havre. Lautrec, on discovering it in July 1899, telegraphed Joyant in Paris for painting equipment so that he could make the most of this new enthusiasm. Miss Dolly, an English actress and singer, sat for this luminous portrait, which stands in such contrast to the Parisian image of *Au 'Rat Mort'* (Plate 76), whose sullen, sinister female differs from Dolly's freshness and vibrance.

(above right)

75 *The Jockey*

PARIS, Bibliothèque Nationale. c. 1899–1900. Coloured lithograph 51 × 36 cm. (Adhémar 365).

Lautrec's youthful interest in horses was renewed in the mid-1890s. In July 1895, for example, he produced four illustrations for Coolus's story *Le bon jockey*, published in *Le Figaro illustré*. This thematic revival became more pronounced as Lautrec fell in with Calmèse, the owner of a livery stable who encouraged the painter's drinking as well as bringing him back into close contact with horses. *The Jockey* was intended to form part of an album of race-track scenes, but only four other prints were completed due to Lautrec's ill health (Adhémar 361–364).

(opposite)

73 *At 'The Star', Le Havre*

SÃO PAULO, Museu de Arte. 1899. Essence on cardboard 54 × 42·5 cm. Monogram as buckle on belt.

This oil sketch was probably the preliminary study for a lithograph of the same subject (Adhémar 358), of which fifty copies were printed. Lautrec usually prepared important lithographs and posters by working them up from trial ideas in pencil and oil. This traditional stalking of the final image, sustained to the last, proves that the artist's procedure was based on a professional rationality, whatever the brio of his hand at the moment of execution. Even the spontaneity of line in this painting is part of an inherent programme, for Lautrec plays off the singer's spiky features and sinuous fingers against the fullness of her low-slung breasts, subjecting the figure to the vicious mannerisms of his late work (Plate 76) and courting an ambiguous mood of frivolity, vice and caricature.

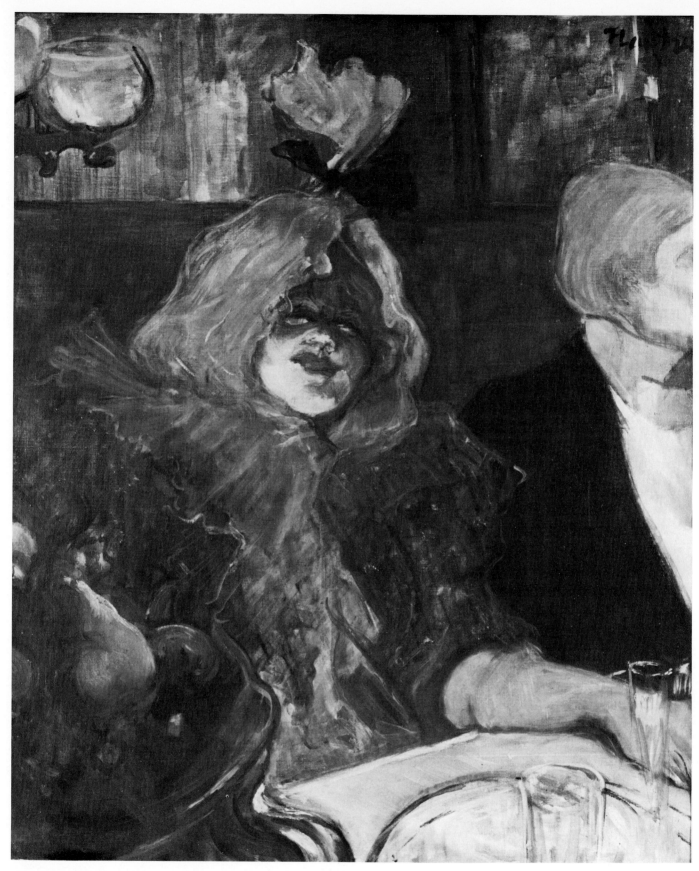

76 *Au 'Rat Mort'*

LONDON, Courtauld Institute Galleries. 1899. Oil on canvas 55 × 46 cm. Signed top right.

The model for this painting, set in Le Rat Mort restaurant near the Place Pigalle, was Lucy Jourdain, a famous *demi-mondaine*. Lautrec did not often paint courtesans, preferring the ordinary *fille* or prostitute. Rothenstein recorded the restaurant fastidiously in his memoirs. 'The Rat Mort by night had a somewhat doubtful reputation, but during the day was frequented by painters and poets. As a matter of fact it was a notorious centre of lesbianism, a matter of which, being very young, and a novice to Paris, I knew nothing. But this gave the Rat Mort an additional attraction

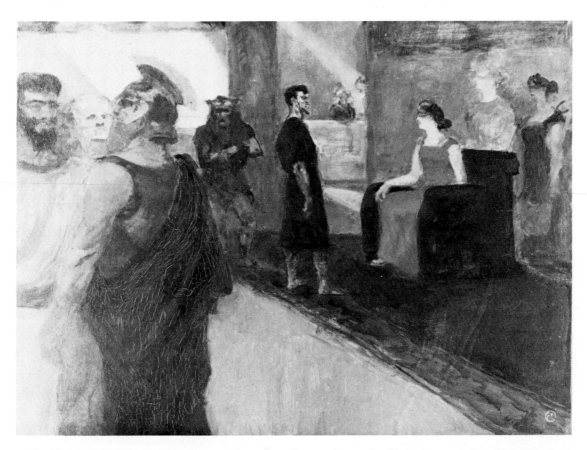

to Conder and Lautrec.' According to the same witness, Anquetin, Dujardin and the old Belgian painter Alfred Stevens were all regular visitors to the place. The composition of the painting bears analogy with the design of *Reine de Joie* (Plate 49). The plump courtesan and her *abonné* are held in the space defined by the diagonals of table and bench-back, while the paint is mixed into etiolated reds and greens, calculated to conjure up the spavined seediness of Lucy Jourdain's fleshy visage. The actual paint surface retains the thinness of *At 'The Star', Le Havre* (Plate 73), also painted in 1899, despite the quieter colour range.

(*above*)
77 *Messaline*
ALBI, Musée Toulouse-Lautrec. 1900. Oil on canvas 46 × 61 cm. Monogram bottom right.

Arriving in Bordeaux in December 1900, Lautrec soon interested himself in the theatre. He enjoyed Mlle. Cocyte in *La belle Hélène* and then Mlle. Ganne in Isidore de Lara's new operetta *Messaline*. Lautrec's last major project as a painter was a series of pictures taken from *Messaline*. Lautrec wrote to Joyant with typical enthusiasm, 'Do you have a photograph of any sort of *Messaline* by Lara? I am fascinated by the play and the better examples of it I can find the better my work will be.' The series of six paintings concentrates on the leading lady, Lautrec's last 'star', and is painted with a broad-brushed tonal approach. The less linear handling tallies with a rather unadventurous composition to give the group an over-determined, studio mood, which nevertheless indicates Lautrec's willingness to experiment, even as his health failed.

(*overleaf*)
78 *Bareback Rider*
PROVIDENCE, Rhode Island School of Design, Museum of Art (gift of Mrs. Murray S. Danforth). 1899. Black, blue, orange and green crayon with grey wash 48·9 × 31·5 cm. Monogram top right and bottom left.

In 1899 Lautrec was confined to Doctor Sémelaigne's clinic in Neuilly to have treatment for his rampant alcoholism and disturbed behaviour. He asked Joyant to send him crayons so that he could work in the nursing home, and produced the forty-odd drawings of *The Circus* series. All these were executed from memory, Lautrec's mind a rich storehouse of images from the past, and were intended to prove to his doctors that he had kept his sanity. With the *Bareback Rider* Lautrec returned to an old theme (Plate 20), but his imagery had undergone a change. The frail figure of the girl rides an extraordinary horse, a nightmare animal with a solid musculature and sinister stiffness. This giant is the core of the drawing. The circus setting is established by the sparest of means, the curve of the arena defining space and only the ringmaster's feet indicating the level of the floor. And, as in most of the other drawings of this series, the performance takes place before no audience.

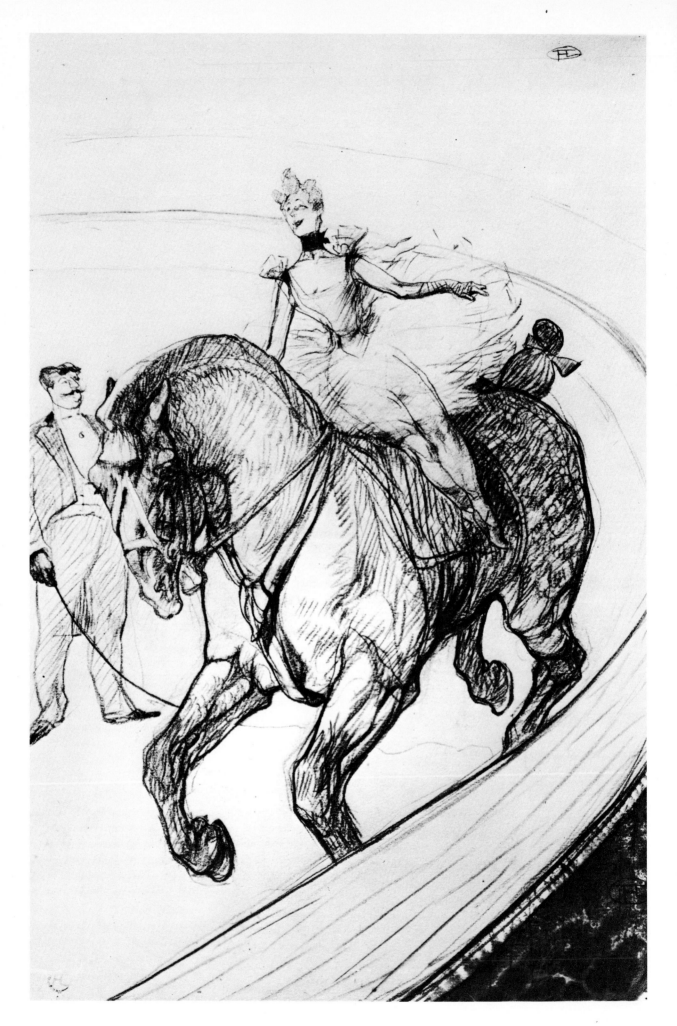